A BEGINNER'S GUIDE TO
COLORED PENCIL
DRAWING

Realistic Drawings in 14 Easy Lessons!

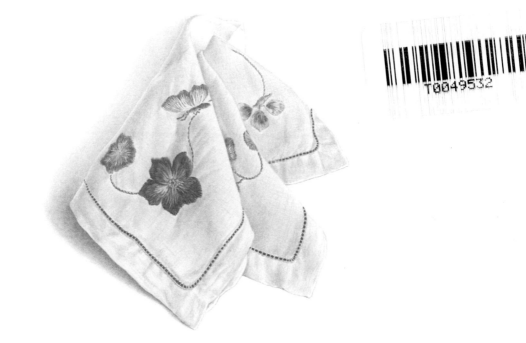

Yoshiko Watanabe

TUTTLE Publishing

Tokyo | Rutland, Vermont | Singapore

Contents

Part 3: Practical Lessons
Drawing Simple Subjects

Part 4: Challenge Yourself
Drawing Complex Subjects

Enjoy learning at your own pace!

Essential Tools

Here are the tools you will need to get started working on the exercises in this book.

Colored Pencils

Colored pencils are available from various manufacturers, but it's fine to start with ones that are easily available to you. In this book, Faber-Castell's Polychromos oil-based colored pencils (36-color set) are used, along with two colors from the Holbein colored pencil range.

Faber-Castell Polychromos (36-color set)

Holbein Artists' Pencils – 2 colors (HB422 Lilac and HB122 Jaune Brillant)

Color Descriptions

The color ID numbers used in this book refer to Polychromos and Holbein. If you are using different colored pencils, please look at the color examples and select similar colors.

Color Needed

Color example

156 Cobalt Green ← Polychromos color number
Polychromos color name

Color example

HB122 Jaune Brillant ← Holbein color number (starts with HB)
Holbein color name

Pencil Sharpener

Always keep a pencil sharpener handy. Sharpen the colored pencils frequently to keep the tips ready to go.

Erasers (Pen-style, Plastic, Etc.)

Erasers are used to remove some of the applied color to create a specular highlight effect. Make sure you have a pen-style eraser and a plastic (vinyl) eraser—a kneaded eraser is useful too.

Pen-style eraser

Plastic eraser

Kneaded eraser

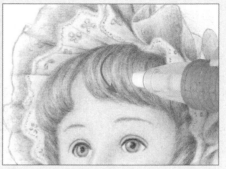

Erasing in a straight line creates the impression of shine along a cylinder.

Erasing along the flow of a doll's hair gives it a lustrous look.

Tissue Paper and Cotton Swabs

Fold a piece of tissue paper into a small wad and use it to blend where the colors meet to create a smooth gradient. It's fine to use cotton swabs for this purpose too.

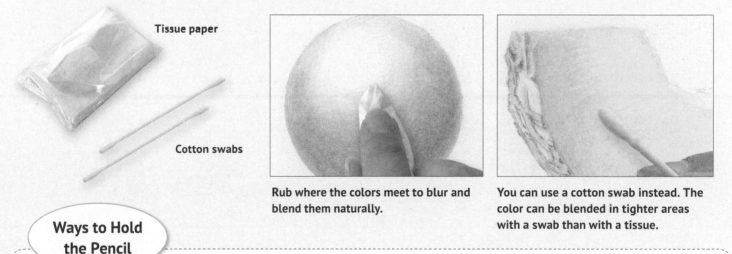

Tissue paper

Cotton swabs

Rub where the colors meet to blur and blend them naturally.

You can use a cotton swab instead. The color can be blended in tighter areas with a swab than with a tissue.

Ways to Hold the Pencil

In principle, colored pencils are held with a relaxed grip in an extended position and colors are applied gradually using a gentle touch. Depending on what you are drawing, change the angle of the pencil and adjust the pressure you apply.

Holding the pencil at a shallower angle and with an extended grip makes it easier to control when coloring a large area.

✓ Shallow angle

✓ Steep angle

Holding the pencil at a steep angle makes it easier to color small areas and to render fine details.

Why I Wrote This Book

I started creating colored pencil drawings more than ten years ago. It all began when an acquaintance invited me to an art class where we'd be "drawing with color." At the time, colored pencil drawing was not as commonplace as it is now. I wondered what type of class it would be. Would we be using crayons like young children do?

I had done some oil painting before, but it was a hassle to prepare to use the medium, not to mention cleaning up afterward—where brushes and palettes needed to be meticulously cleared of the sticky oil paint. With colored pencil drawing, however, it was really simple to get started. I just popped open the case, chose a colored pencil, and I was ready to begin! To clean up at the end, all I had to do was return the pencils to the case and then put that in my bag. It was so easy!

What made it even more appealing was the rich variety of colors the pencils came in! Just choosing my favorite colors from among the huge range available was enjoyable. When I tried layering different colors on top of each other, I discovered I could create surprisingly rich blends. It was so much fun, I got hooked!

I began to learn one thing after another: that it's better to use a pencil with a slightly softer core when layering colors; that it's important to control the angle of the pencil and the pressure you exert so you can achieve the kind of line quality that you're after; that gradually layering light colors provides a superior finish; and that using ingenuity with colors, shadows and highlights can create very realistic expressions. I got really absorbed in the process of creating colored pencil art and kept saying, "this is fun!"

In this book, I've drawn from my experience to prepare a variety of exercises that even beginners can use to enjoy drawing with colored pencils. Each exercise is accompanied by an example, and the colors used are explained in detail—step by step. This book is designed so you can master the skills in 14 days (at the rate of one lesson per day), but it's fine to go at your own pace without pushing yourself. I think you will make many wonderful discoveries while completing the exercises.

I'm confident that by using this book, you too will find that colored pencils are fun!

—**Yoshiko Watanabe**

Part 1: The Basics

Learning to Use Colored Pencils

Lesson 1: Basic Practice ①–⑨

Let's start with some easy basic practice.

Basic Practice Exercises ①–⑥

In this section, we'll practice drawing lines, applying different pressure and coloring evenly. The aim here is to become familiar with using colored pencils by completing simple tasks.

Basic Practice Exercises ⑦–⑨

In this section, we'll practice the unique color combination method for colored pencils and color gradation, which creates a smooth change in shades. While the tasks will increase in difficulty gradually, try to relax and enjoy doing them.

Practice Drawing Lines

GOAL First, let's start by drawing lines. When people draw for the first time with a colored pencil, they often find it difficult to control because they either apply too much or too little pressure. Let's practice drawing lines, starting with fine faint ones using very little pressure, and then applying more pressure to create thicker, bolder lines.

⚑ Drawing Lines Using Different Pressures

Here, we'll practice drawing lines by applying different levels of pencil pressure. Try drawing lines in 5 steps, using pencil pressure that ranges from Level 1 to Level 5. As long as you're aware of the pressure you're drawing with, it's fine if you don't have complete control of the pencil. Once you've drawn the lines for the 5 steps, try drawing the spirals while changing the level of pressure.

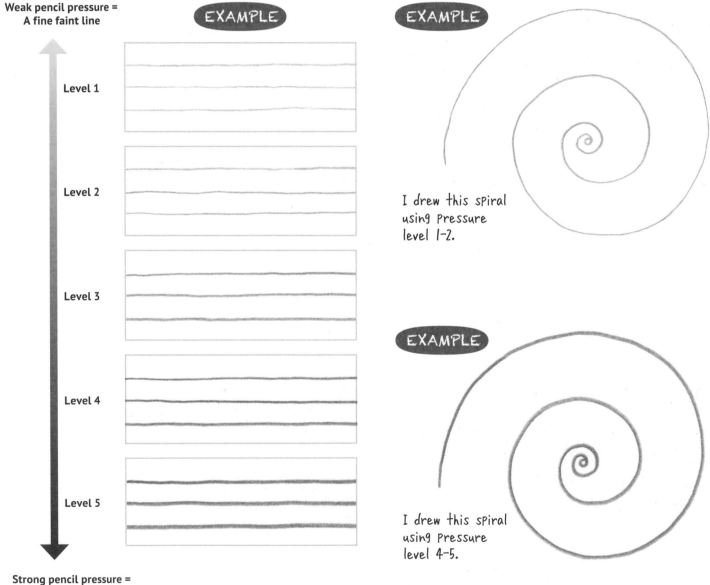

Weak pencil pressure =
A fine faint line

EXAMPLE

Level 1

Level 2

Level 3

Level 4

Level 5

Strong pencil pressure =
A thick bold line

EXAMPLE

I drew this spiral using Pressure level 1–2.

EXAMPLE

I drew this spiral using Pressure level 4–5.

Your Turn

Practice coloring while referring to the examples.

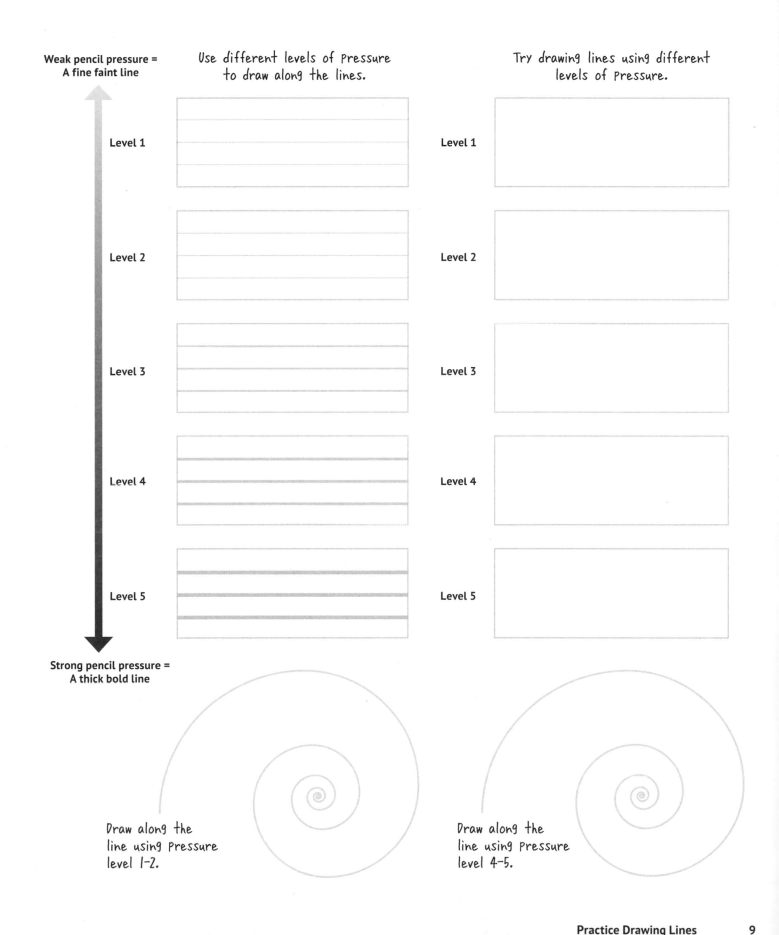

Weak pencil pressure =
A fine faint line

Use different levels of Pressure to draw along the lines.

Try drawing lines using different levels of Pressure.

Level 1

Level 2

Level 3

Level 4

Level 5

Strong pencil pressure =
A thick bold line

Draw along the line using Pressure level 1-2.

Draw along the line using Pressure level 4-5.

Practice Adding Color Evenly

GOAL It's fine to freely enjoy using colored pencils, but if you can color evenly, you will expand your range of expression further and it will become even more fun.

Three Basic Coloring Methods

To color large areas evenly with colored pencils, you need to layer the lines over and over again. If you layer many thin lines using even pressure throughout, you can create beautifully smooth tones. The three coloring methods introduced here are basic ones that can be used for a variety of subjects, so let's practice.

Ⓐ Uni-directional Lines

Using uniform pressure, move the colored pencil in the same direction again and again. Layer the color so that the gaps are gradually filled in. This technique is mainly useful for coloring edges and borders, places where, if not colored carefully, the color will stray outside the lines.

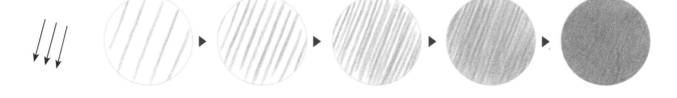

Ⓑ Zigzagging

Using uniform pressure, move the colored pencil over and over in a zigzagging pattern. Layer the color so that the gaps are gradually filled in. This is useful for coloring large areas where you don't need to be so precise about applying the color.

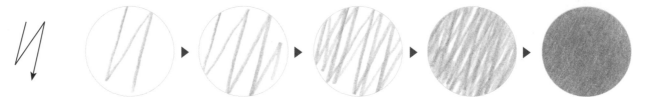

Ⓒ Looping

Using uniform pressure, move the colored pencil in continuous loops. Layer the color so that the gaps are gradually filled in. If you combine this with methods Ⓐ and Ⓑ, and keep changing the amount of pressure you apply, you can create a variety of textures.

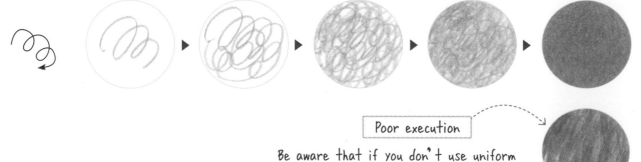

Poor execution

Be aware that if you don't use uniform pressure, the shading will be uneven.

Your Turn

Practice coloring while referring to the examples on the facing page.

Ⓐ Uni-directional Lines

Let's practice a few times Try using different colors too

Ⓑ Zigzagging

Let's practice a few times Try using different colors too

Ⓒ Looping

Let's practice a few times Try using different colors too

> **Quick Tip**
>
> The best way to color smoothly and evenly is not to rush it using strong pressure, but to carefully apply many layers using light pressure!

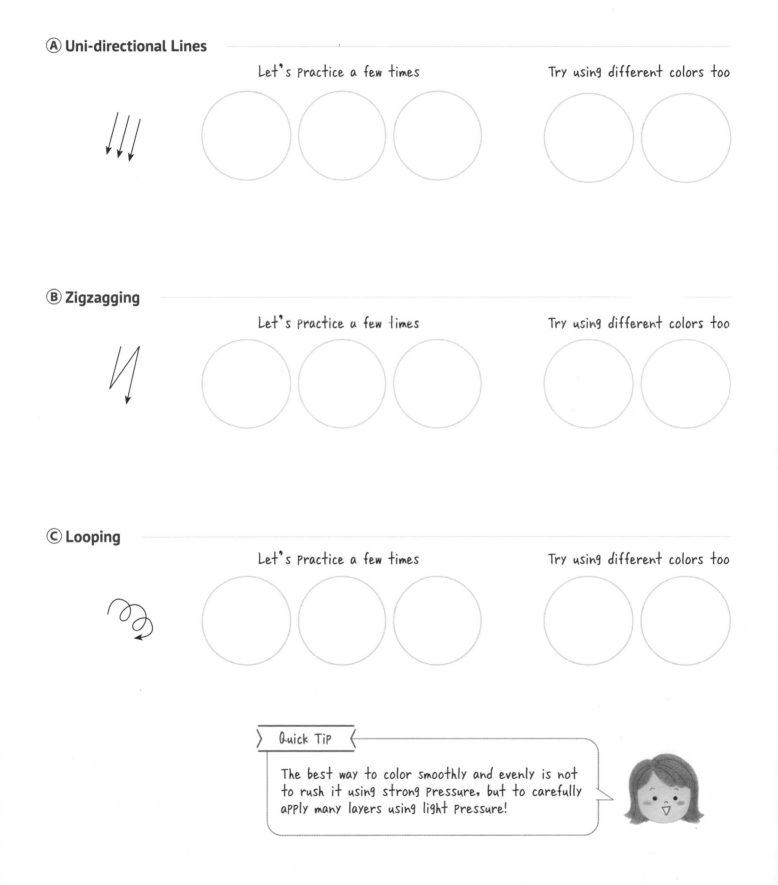

Practice Drawing in Various Shades

(GOAL) **In the previous exercise, we learned that to apply colors evenly, you need to layer lines over and over using uniform pressure. Here we will go one step further and practice controlling shading by continuously layering light colors. Being able to freely control shades means you can create a wide range of expressions with just one color.**

⚑ Fill in Color from Light to Dark Shades

Color shading is expressed through the difference in the number of times a color is layered. Let's try layering light colors using a pencil pressure of level 1–2 to create darker shades. It's fine to use any of the three basic coloring methods introduced in the previous exercise.

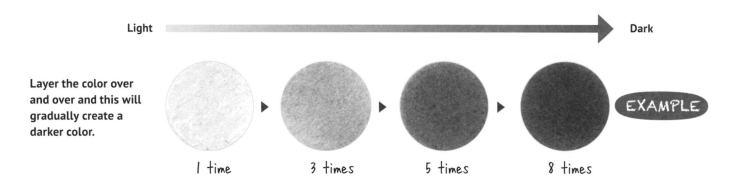

Layer the color over and over and this will gradually create a darker color.

| 1 time | 3 times | 5 times | 8 times |

⚑ Fill in Color in Order from Light → Dark → Medium

Using the method described above, first color light area ①, then leave a space and color dark area ③. Finally, color in that middle space ②. Color it a medium shade, making sure that it becomes a shade midway between ① and ③. Practicing this will give you a sense of control over shading.

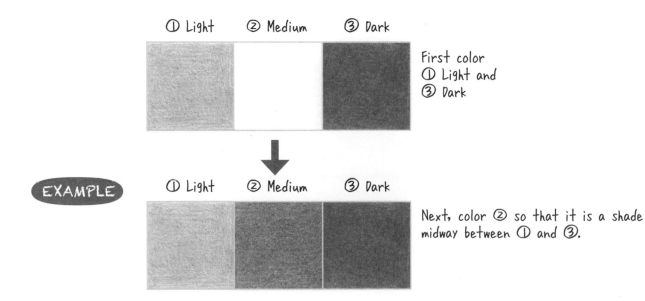

① Light　② Medium　③ Dark

First color
① Light and
③ Dark

① Light　② Medium　③ Dark

Next, color ② so that it is a shade midway between ① and ③.

⚑ Your Turn

Practice coloring while referring to the examples on the facing pages.

✓ Color from Light to Dark Shades

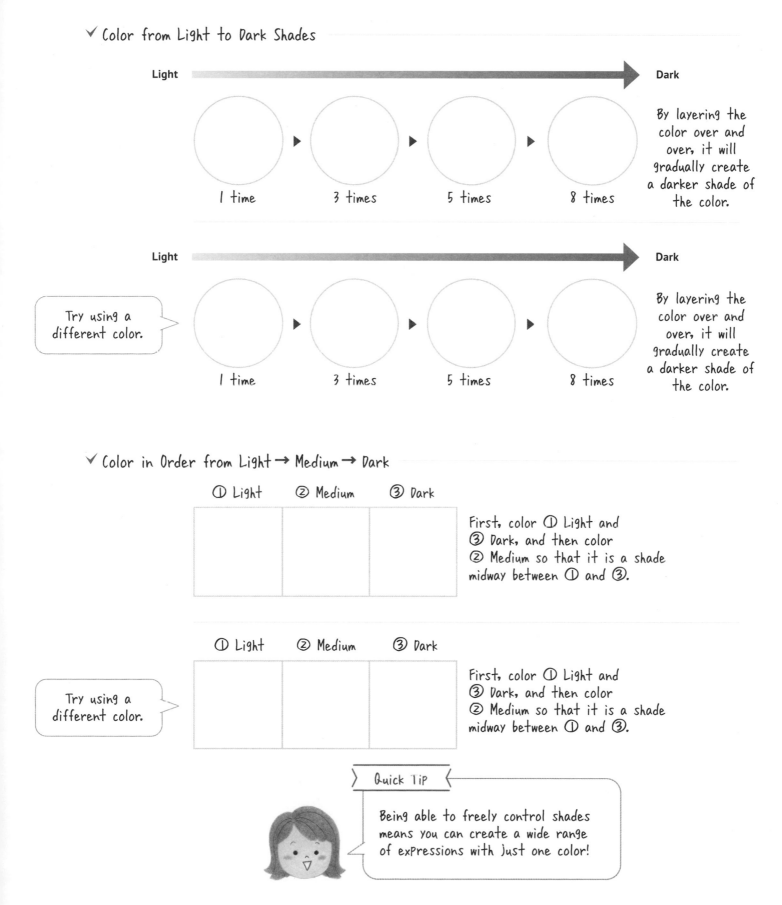

Light ➞ **Dark**

| 1 time | 3 times | 5 times | 8 times |

By layering the color over and over, it will gradually create a darker shade of the color.

Light ➞ **Dark**

Try using a different color.

| 1 time | 3 times | 5 times | 8 times |

By layering the color over and over, it will gradually create a darker shade of the color.

✓ Color in Order from Light ➞ Medium ➞ Dark

① Light ② Medium ③ Dark

First, color ① Light and ③ Dark, and then color ② Medium so that it is a shade midway between ① and ③.

① Light ② Medium ③ Dark

Try using a different color.

First, color ① Light and ③ Dark, and then color ② Medium so that it is a shade midway between ① and ③.

⟩ Quick Tip ⟨

Being able to freely control shades means you can create a wide range of expressions with just one color!

Practice Different Coloring Methods

> **GOAL** There are various other ways to color apart from the three basic coloring methods you practiced on page 10. You can express various textures by using different coloring methods, depending on the subject you are drawing.

Various Coloring Methods to Remember

Here are a number of methods that are often used along with the three basic coloring methods on page 10.

D Cross-hatching

Draw a layer of uni-directional lines, and then add another layer of uni-directional lines that cross over the first ones at an angle. This makes it easy to increase the density uniformly, and by coloring roughly you can create a coarse texture, which is useful for things like a loaf of French bread.

EXAMPLE

Make uni-directional lines.

Change the angle and add more uni-directional lines.

Continue layering uni-directional lines at different angles.

E Gathered Lines

Draw a lot of short fine vertical lines, layering them so they are close to each other. By using different pencil pressures, you can create a variety of shades. This is an easy way to create roundness and indicate curves, so it's useful for coloring apples.

EXAMPLE

Make fine vertical lines.

Layer a lot of them so they are closely bunched together.

Complete

F Fluffy Lines

Drawing fine lines in many layers and in random directions, using a light touch, creates a soft, fluffy appearance. This is useful for coloring fine, soft items, such as animal hair.

EXAMPLE

Make fine lines using a light touch.

Layer a lot of lines in random directions.

Complete

G Rough Lines

Move the tip of the pencil in small motions and draw lines that have a lot of random angles ("squiggles"). If you layer a lot of these, it will create a rough impression. This is useful when creating the expression of rough surfaces like coating for croquettes.

EXAMPLE

Draw lines that have a lot of angles.

Layer a lot of lines.

Complete

Your Turn

Practice coloring while referring to the examples on the facing page.

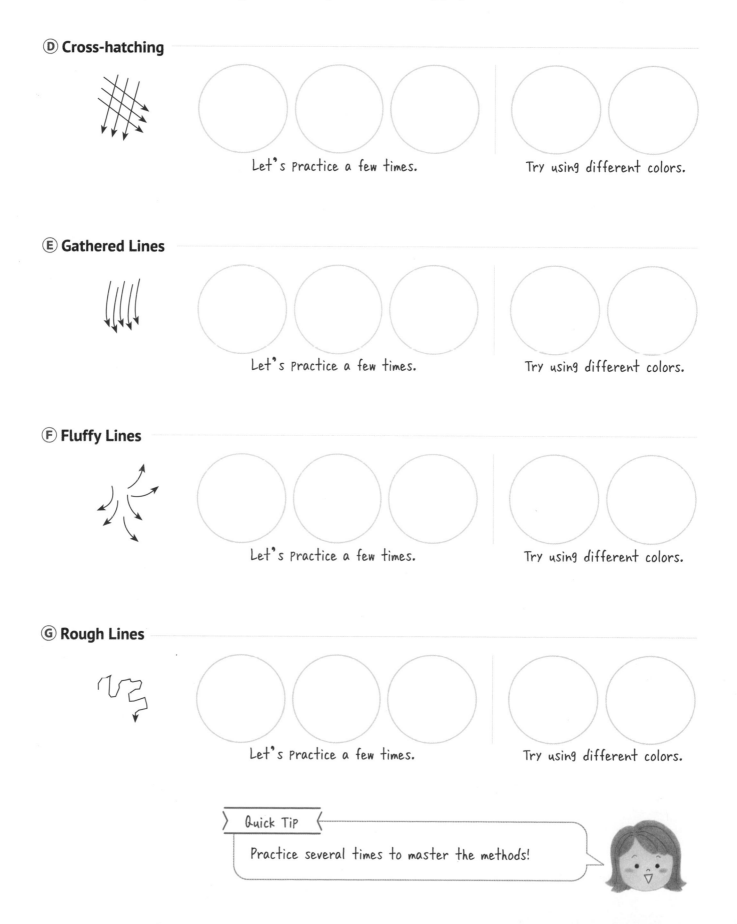

Ⓓ **Cross-hatching**

Let's practice a few times.

Try using different colors.

Ⓔ **Gathered Lines**

Let's practice a few times.

Try using different colors.

Ⓕ **Fluffy Lines**

Let's practice a few times.

Try using different colors.

Ⓖ **Rough Lines**

Let's practice a few times.

Try using different colors.

⟩ Quick Tip ⟨

Practice several times to master the methods!

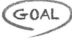

Try Drawing Various Shapes

GOAL **In this exercise, we'll summarize the practice we've done so far and practice coloring various shapes, so the colors remain even and stay within the lines.**

🚩 Drawing to Stay Within the Lines

Place the colored pencil inside the outline of the shape so that the color doesn't stray outside. Start coloring in directional lines along the outline, and then gradually move toward the center. It helps to turn the paper while drawing to make it easier to apply the color.

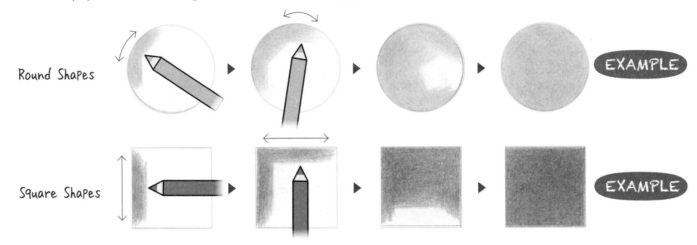

Round Shapes ▸ ▸ ▸ EXAMPLE

Square Shapes ▸ ▸ ▸ EXAMPLE

🚩 Try Coloring Simple Designs

Use the same technique to color various shapes without going outside the lines.

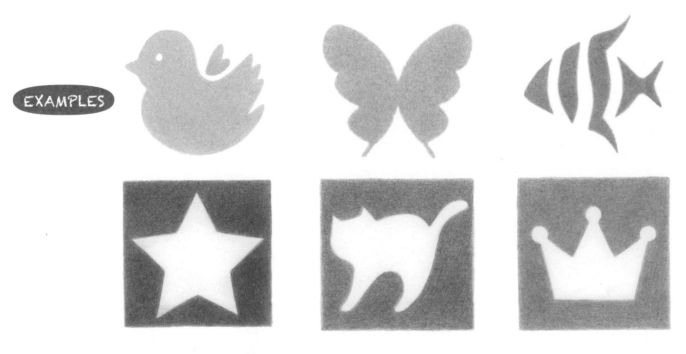

EXAMPLES

Your Turn

Practice coloring while referring to the examples on the facing page.

Color without going outside the lines. Go ahead and use your favorite colors.

> **Quick Tip**
>
> Don't try to color a large area all at once. The trick is to go little by little, keeping the pressure constant and using short strokes!

Create a Flower-shaped Color Chart

GOAL The next theme we'll explore at is combining colors and color gradation. Let's start by creating a 38-color flower-shaped color chart. As long as you can get some sense of the relationship between the colors while making this color chart, it's a worthwhile exercise.

Flower-shaped Color Chart

The chart below shows 38 colors arranged in a flower shape, using a hue circle, based on color theory. The colors are divided into 12 groups: Red; Purplish-red; Bluish-purple; Blue; Blue-green; Green; Yellow-green; Yellow; Orange; Orange-red; Monochrome and Gray. Color each group in turn.

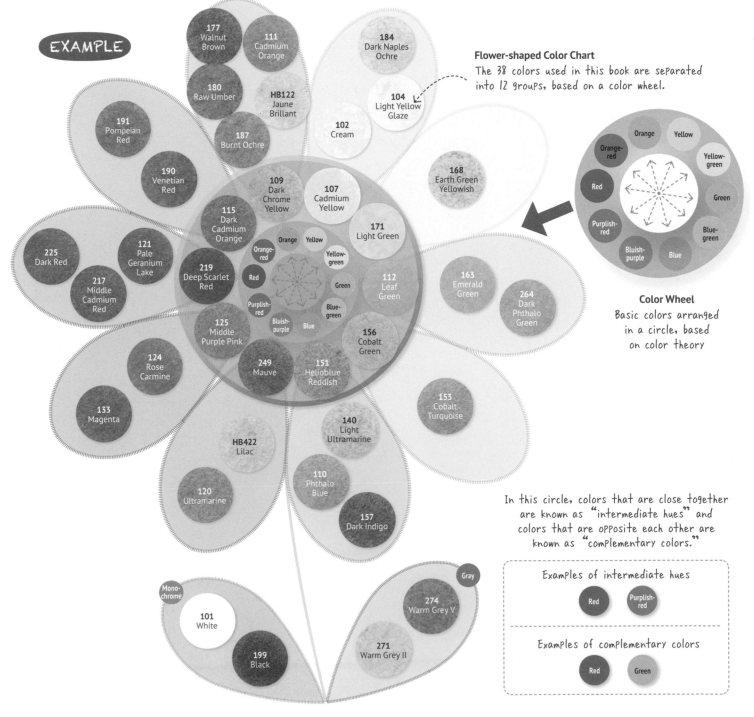

EXAMPLE

Flower-shaped Color Chart
The 38 colors used in this book are separated into 12 groups, based on a color wheel.

Color Wheel
Basic colors arranged in a circle, based on color theory

In this circle, colors that are close together are known as "intermediate hues" and colors that are opposite each other are known as "complementary colors."

Examples of intermediate hues

Examples of complementary colors

Your Turn

Color while referring to the example on the facing page. This exercise will build a sense of the relationship between the colors.

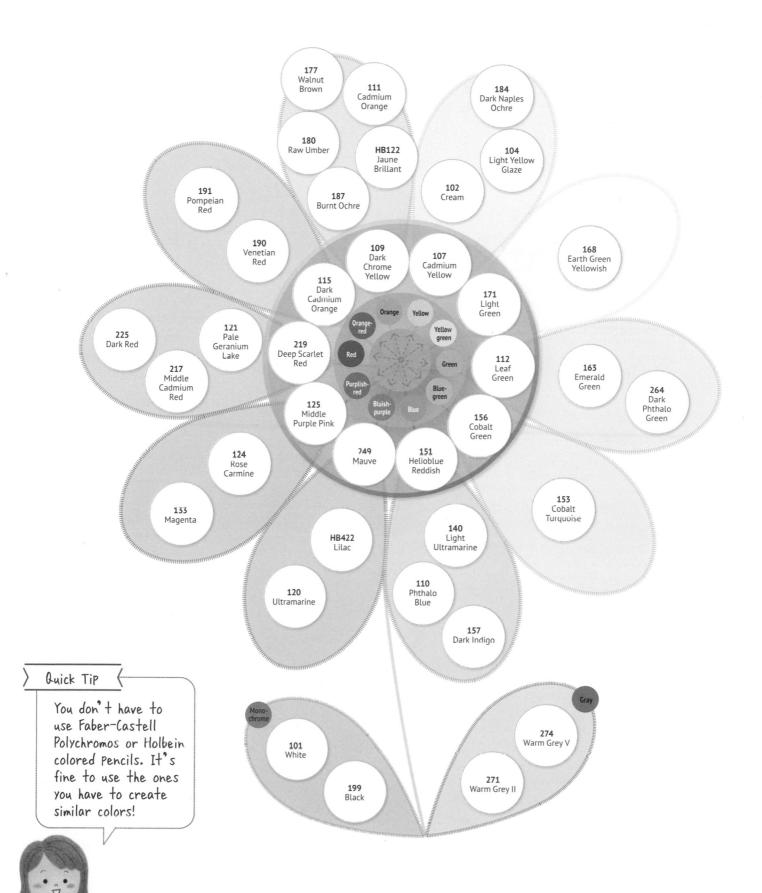

Quick Tip

You don't have to use Faber-Castell Polychromos or Holbein colored pencils. It's fine to use the ones you have to create similar colors!

Learn to Combine Colors

GOAL With colored pencils, you can combine colors by applying multiple colors in layers. Unlike watercolors where you mix the colors on a palette to combine them, in principle here the first color you apply will be dominant.

🚩 Layering Two Colors to Create a Blend

Color A and B in yellow, and then color B and C in red. Area B will become orange.

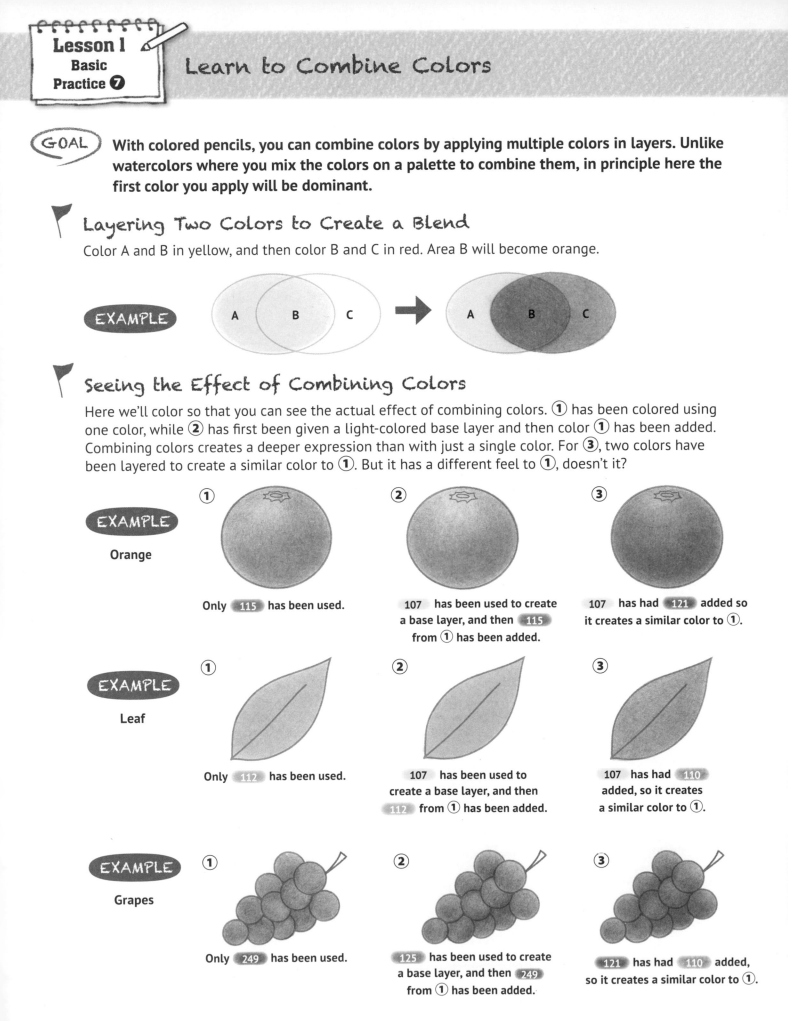

EXAMPLE

🚩 Seeing the Effect of Combining Colors

Here we'll color so that you can see the actual effect of combining colors. ① has been colored using one color, while ② has first been given a light-colored base layer and then color ① has been added. Combining colors creates a deeper expression than with just a single color. For ③, two colors have been layered to create a similar color to ①. But it has a different feel to ①, doesn't it?

EXAMPLE

Orange

① Only 115 has been used.

② 107 has been used to create a base layer, and then 115 from ① has been added.

③ 107 has had 121 added so it creates a similar color to ①.

EXAMPLE

Leaf

① Only 112 has been used.

② 107 has been used to create a base layer, and then 112 from ① has been added.

③ 107 has had 110 added, so it creates a similar color to ①.

EXAMPLE

Grapes

① Only 249 has been used.

② 125 has been used to create a base layer, and then 249 from ① has been added.

③ 121 has had 110 added, so it creates a similar color to ①.

Your Turn

Practice coloring while referring to the examples on the facing page.

✓ Layering Two Colors to Create a Blend

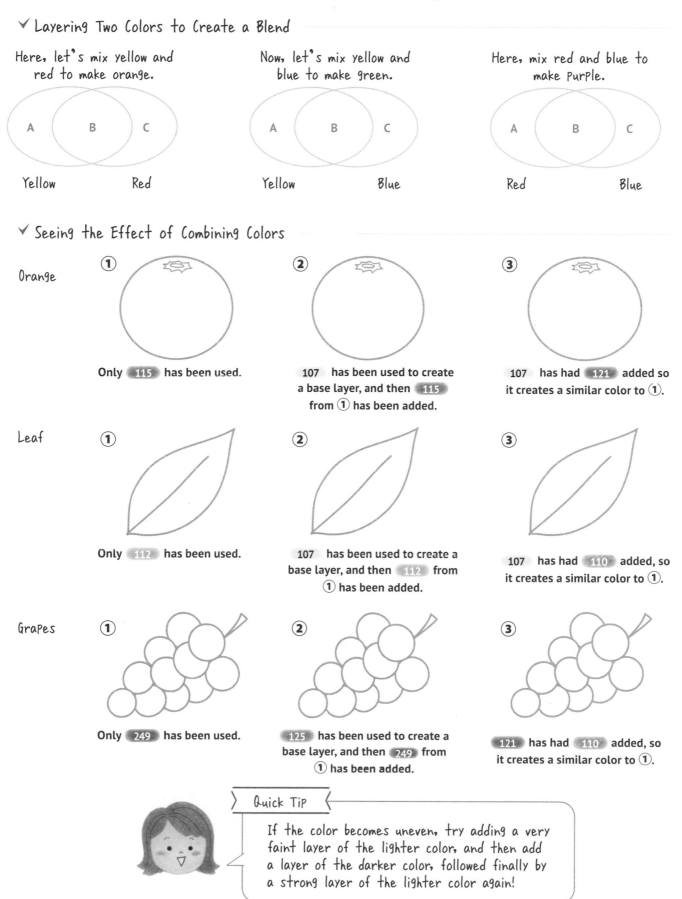

Here, let's mix yellow and red to make orange.

A B C

Yellow Red

Now, let's mix yellow and blue to make green.

A B C

Yellow Blue

Here, mix red and blue to make purple.

A B C

Red Blue

✓ Seeing the Effect of Combining Colors

Orange

① Only 115 has been used.

② 107 has been used to create a base layer, and then 115 from ① has been added.

③ 107 has had 121 added so it creates a similar color to ①.

Leaf

① Only 112 has been used.

② 107 has been used to create a base layer, and then 112 from ① has been added.

③ 107 has had 110 added, so it creates a similar color to ①.

Grapes

① Only 249 has been used.

② 125 has been used to create a base layer, and then 249 from ① has been added.

③ 121 has had 110 added, so it creates a similar color to ①.

> **Quick Tip**
>
> If the color becomes uneven, try adding a very faint layer of the lighter color, and then add a layer of the darker color, followed finally by a strong layer of the lighter color again!

Practice Creating Color Gradations

GOAL Color gradation is a technique where colors and shades change smoothly and continuously. It's an often-used technique in colored pencil art, so let's practice mastering it.

The Color Gradation Process

To create color gradation, first lightly color the whole area. Next, gradually layer the color from the darker side to the lighter side, using gentle pressure. Increase the number of times you layer the color on the darker side or slightly increase the pencil pressure to get an overall balance and create beautiful gradation.

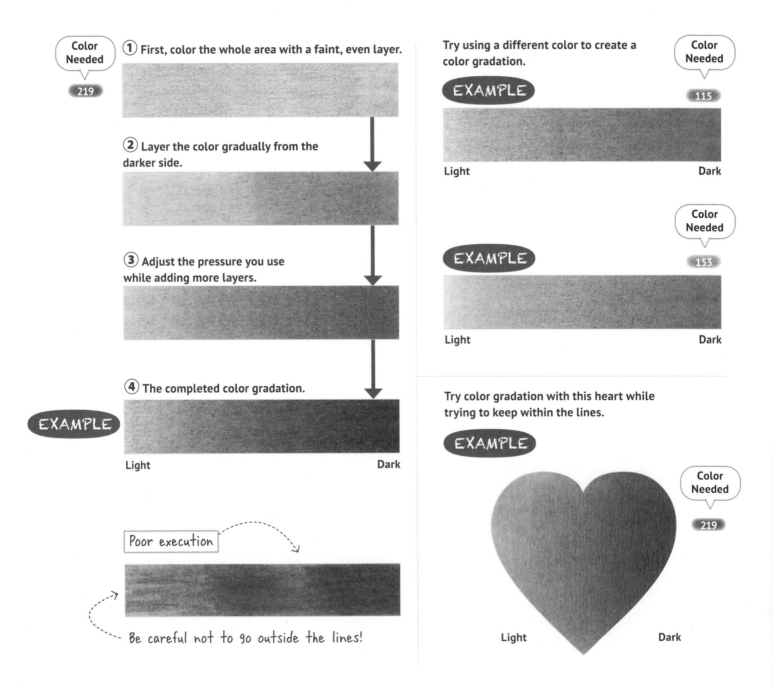

Color Needed 219

① First, color the whole area with a faint, even layer.

② Layer the color gradually from the darker side.

③ Adjust the pressure you use while adding more layers.

④ The completed color gradation.

EXAMPLE

Light Dark

Poor execution

Be careful not to go outside the lines!

Try using a different color to create a color gradation.

EXAMPLE Color Needed 115

Light Dark

EXAMPLE Color Needed 153

Light Dark

Try color gradation with this heart while trying to keep within the lines.

EXAMPLE

Color Needed 219

Light Dark

Your Turn

Practice coloring several times while referring to the examples on the facing page.

Single color gradation

Light Dark Light Dark

Light Dark Light Dark

Try using a different color to create a color gradation while referring to the examples on the facing page.

Light Dark

Try color gradation with this heart while trying to keep within the lines.

Light Dark

Light Dark

Light Dark

Light Dark

> Quick Tip <

Layer the colors carefully and gradually to create a smooth gradation!

Creating Complex Colors Using Gradations

GOAL Choose several colors that are close to each other or in the same color group from the flower-shaped color chart (page 18) and try creating multiple color gradation. You can create deeper expression than with just single-color gradation.

Two-color Gradation

Using the lightest color from the colors you have chosen, begin by applying a faint layer to slightly beyond the midpoint along the given area. Then, add the next color from that halfway mark so that it overlaps the first color. Finally, add a very faint layer of the first color over the entire area to adjust the whole tone.

125 and 249 gradation

Examples of other 2-color gradations

① Light
Color using 125 to the midpoint.

EXAMPLE

140 110

② Light Dark
Layer 249 over from the midpoint.

EXAMPLE

109 187

③
125 Add 125 very faintly over 249 the entire area to complete.

EXAMPLE

171 112

Three-color Gradation

Three color gradation is created in the same way as two-color gradation. Where the colors meet, try to color so that they blend naturally.

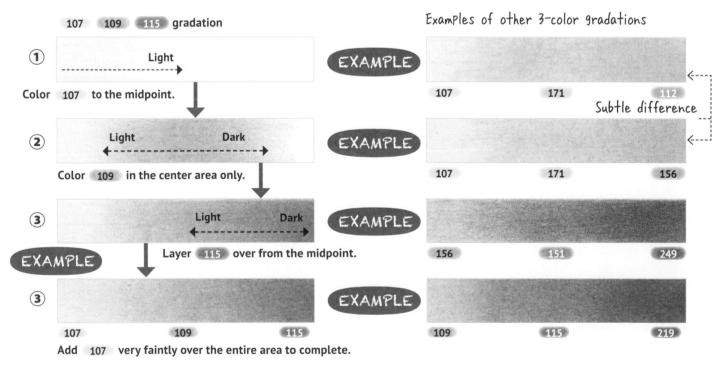

107 109 115 gradation

Examples of other 3-color gradations

① Light
Color 107 to the midpoint.

EXAMPLE

107 171 112
Subtle difference

② Light Dark
Color 109 in the center area only.

EXAMPLE

107 171 156

③ Light Dark
Layer 115 over from the midpoint.

EXAMPLE

156 151 249

③
107 109 115
Add 107 very faintly over the entire area to complete.

EXAMPLE

109 115 219

Your Turn

Practice coloring while referring to the examples on the facing page.

✓ Two-color Gradation

125 249 140 110

109 187 171 112

Choose 2 colors you like and have a try.

✓ Three-color Gradation

107 109 115 107 171 112

107 171 156 156 151 249

Choose 3 colors you like and have a try.

109 115 219

Quick Tip

Add the colors so that they blend smoothly and don't show abrupt changes where they overlap!

Yoshiko Watanabe's Colored Pencil Picture Gallery #1: Beautiful Flowers

Sweet Pea

Poppy

Tulip

Colored Pencil Drawing Techniques

Lesson 2: Expressing 3D Forms ①—④

Here, we'll practice expressing three-dimensional effects to create more realistic drawings. The quickest way to improve is to understand the relationship between light, shadow and shading.

Lesson 3: Smooth Surfaces ①—④

In these exercises, we'll practice drawing different expressions of texture for materials like ceramic, metal, glass and wood.

Lesson 4: Rough Surfaces ⑤—⑧

Here, we'll practice drawing a wider range of materials like bread, water droplets, cabbage leaves and animal fur. Learn how to depict each unique texture.

Drawing Spheres

GOAL For Lesson 2, we'll practice expressing three-dimensional effects.

⚑ Light, Shadow, Shade and Highlights

When creating a three-dimensional effect, it's important to express the light and shadow accurately. Take a look at the illustration of the sphere below. When light is blocked by an object, a **shadow** forms on the opposite side of that object from the light source, while the dark area that appears on the object itself is **shading**. The area where the light reflects brightest is known as a **highlight**. By being aware of these points, you can create convincing three-dimensional effects.

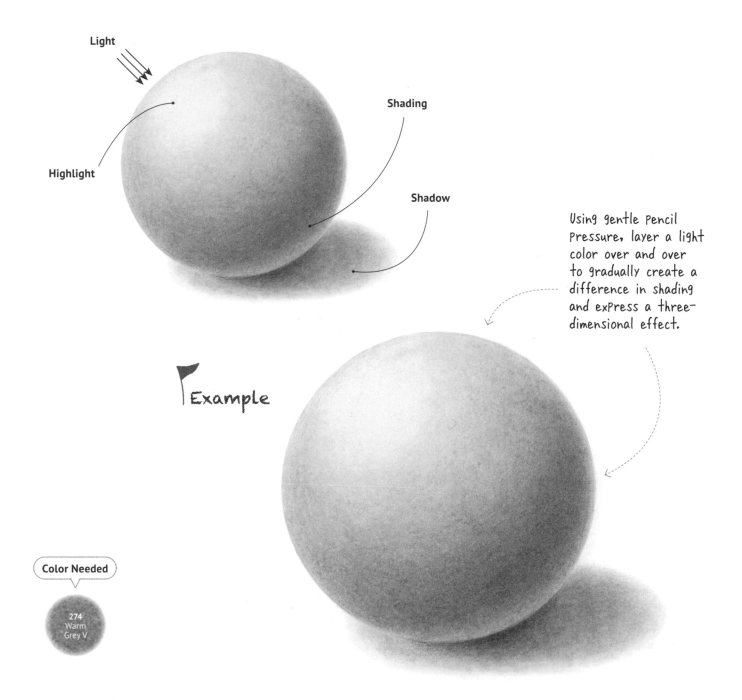

Light

Shading

Highlight

Shadow

Using gentle pencil pressure, layer a light color over and over to gradually create a difference in shading and express a three-dimensional effect.

⚑Example

Color Needed

274
Warm
Grey V

⚑ Try Drawing a 3D Ball

Let's color a ball, while keeping in mind the relationship between **light**, **shadow**, and **shading**. It starts as just a flat circle, but by carefully adding shadow and shading little by little, it gradually becomes a sphere with a three-dimensional effect.

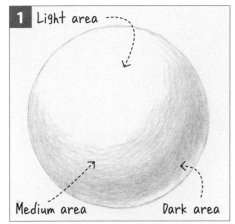

1 Light area
Medium area Dark area

First, identify the light, dark and medium areas and color them broadly.

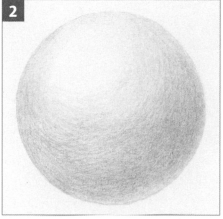

2

Add more light shading to distinguish the highlight in the light area.

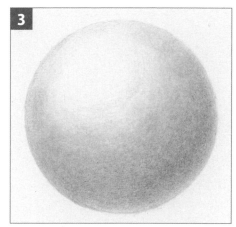

3

Even out the difference in brightness by rubbing and blending the color with the tip of a cotton swab or folded tissue paper.

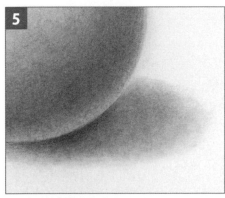

4

A brightened area of reflected light is created where the light bounces off the surface the sphere is resting on. If you reproduce that, it heightens the 3D effect.

Reflected light

The reflected light is created by lightly coloring the whole sphere and then using a kneaded eraser to pull some color away from the area next to the edge.

⚑ Your Turn

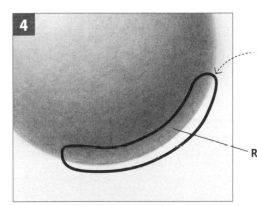

5

For the shadow cast onto the table, use gradation to color the area closest to the ball the darkest, and then color more lightly as you move away from it.

▶ A tear-out practice sheet can be found on page 97.

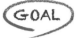

Drawing Cuboids and Cylinders

GOAL Once you've drawn the ball, practice drawing a cuboid and a cylinder, while keeping in mind three-dimensionality. For the cuboid, the key is to color so as to create a contrast in brightness between the three visible surfaces. For the cylinder, use color gradation to express the smooth change in the way light plays on its curved surface.

Example

Cuboid

Light

Light

Color Needed

274
Warm
Grey V

Cylinder

Cuboid

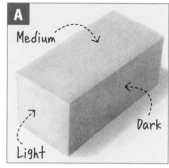

A

Medium

Dark

Light

Color the three surfaces so the brightness of each one is clearly either light, medium or dark. Note that there are areas of subtle brightness on each plane.

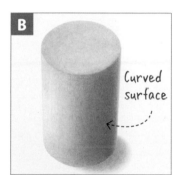

B

Curved surface

Express the smooth change in brightness on the cylinder's curved surface by using color gradation.

C

Slightly lighter

Reflected light will subtly affect the darker vertical edge of the cylinder, so if you make the edge slightly lighter, it will look more realistic.

Key Points for Drawing

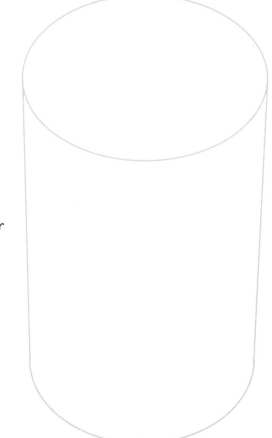

Cylinder

⟩ Quick Tip ⟨

If you add a fine dark shadow to the area where the object meets the surface it's resting on, it will enhance the three-dimensional effect. Be careful not to make it one straight, unvaried line though!

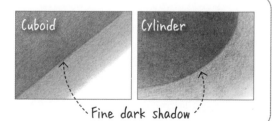

Cuboid Cylinder

Fine dark shadow

▶ A tear-out practice sheet can be found on page 97.

Drawing an Apple

GOAL Let's draw in the color for an apple while keeping in mind the three-dimensional effect we want to exhibit. The direction of the light is different to that of the sphere on page 28, with it shining almost directly from above. While drawing, pay attention to where the shading forms.

❚Example

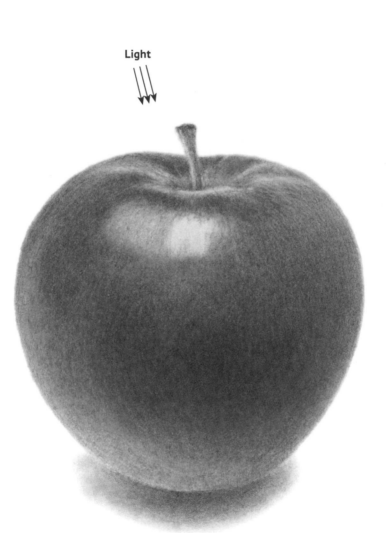

Light

Colors Needed

Apple

102
Cream

121
Pale
Geranium
Lake

107
Cadmium
Yellow

180
Raw
Umber

Stem

180
Raw
Umber

177
Walnut
Brown

Indent

104
Light
Yellow
Glaze

168
Earth
Green
Yellowish

Shadow

274
Warm
Grey V

> Quick Tip <

You can make fruit look more realistic by first using the internal color of the fruit (in this case, 102) as a base layer and then adding the peel's color (121). Apply the base color very lightly!

Process and Key Points

Be aware of the rounded shape.

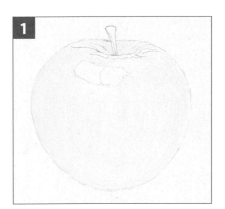

1

Using 102 , lightly color the whole area in a base layer. Leave the highlight (glossy area) white.

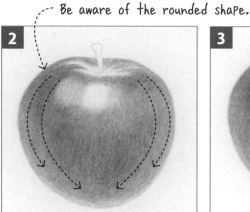

2

Using 121 , color the whole area and add shading, while staying aware of the rounded shape. Don't color the highlight or the stem yet.

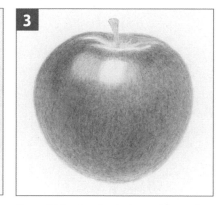

3

Use 104 for the indentation and 180 to lightly color the stem. Then, use 107 to add a light overall layer.

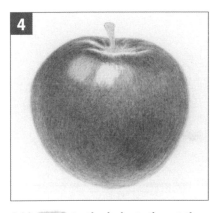

4

Add 168 to the indentation at the top, and then use 121 again to add another overall layer.

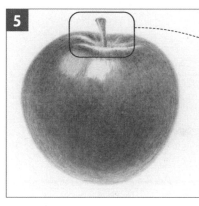

5

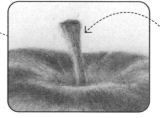

Look carefully at the shading of the stem when drawing.

Use 177 to add shadow to the stem and use 107 and 121 to make fine adjustments to the color of the fruit.

Your Turn

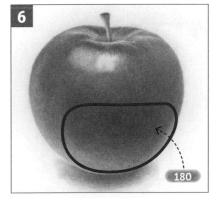

6

Adjust the overall shading more using 102 , 121 and 107 . Use 180 to add faint shading near the base of the fruit. Add the diffuse shadow using 274 beneath the fruit to complete.

▶ A tear-out practice sheet can be found on page 101.

Drawing Candy-coated Chocolate Drops

GOAL To create the surface of the candy-coated chocolate drops, place the tip of the pencil nearly on its side and gently apply a thin layer to express the glossy, smooth texture. Note that where drops are close to one another, the colors will slightly reflect onto each other.

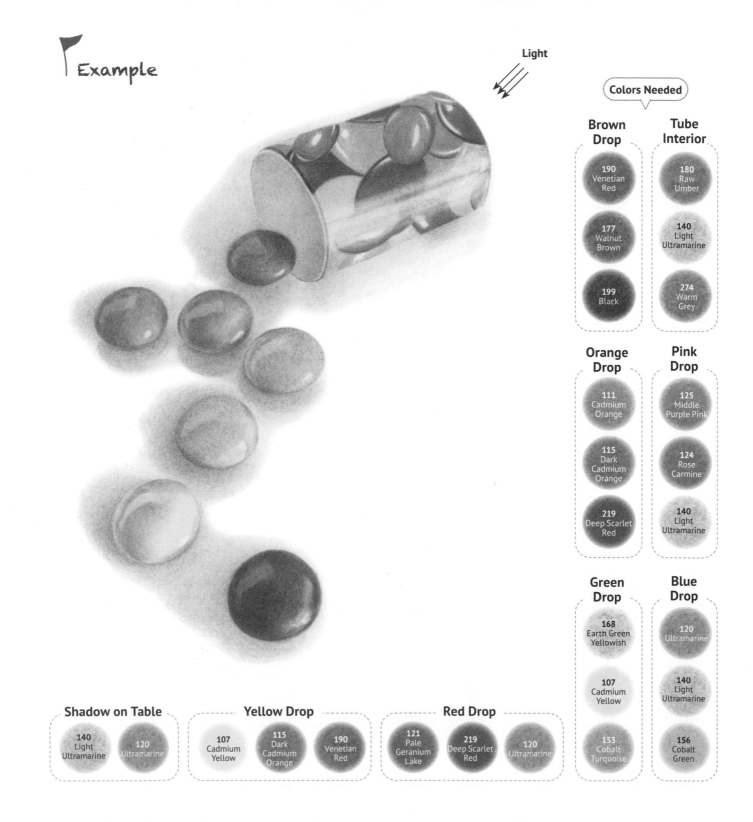

Example

Light

Colors Needed

Brown Drop
- 190 Venetian Red
- 177 Walnut Brown
- 199 Black

Tube Interior
- 180 Raw Umber
- 140 Light Ultramarine
- 274 Warm Grey

Orange Drop
- 111 Cadmium Orange
- 115 Dark Cadmium Orange
- 219 Deep Scarlet Red

Pink Drop
- 125 Middle Purple Pink
- 124 Rose Carmine
- 140 Light Ultramarine

Green Drop
- 168 Earth Green Yellowish
- 107 Cadmium Yellow
- 153 Cobalt Turquoise

Blue Drop
- 120 Ultramarine
- 140 Light Ultramarine
- 156 Cobalt Green

Shadow on Table
- 140 Light Ultramarine
- 120 Ultramarine

Yellow Drop
- 107 Cadmium Yellow
- 115 Dark Cadmium Orange
- 190 Venetian Red

Red Drop
- 121 Pale Geranium Lake
- 219 Deep Scarlet Red
- 120 Ultramarine

Key Points for Drawing

Remove with an eraser

A

B

C
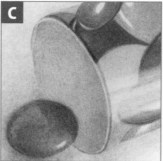

D
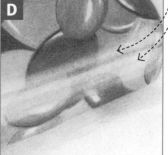

The 3D effect of the drops is expressed through the difference in brightness on the surface and the shape of the highlight. For the red drop, use `121` as a base layer and layer `219` to create a three-dimensional effect. For the shading, layer with `120`. Create a strong shine by leaving the highlight white or for a weaker shine, color it lightly.

For the shadows of the scattered drops on the table, express it using color gradation with `140` and `120`. Where the reflection of the candy color stands out, add that color too to express realism.

Use `180`, `140` and `274` for the shading inside the tube. Make sure the walls of the tube look like they are curving.

To create the highlight, color normally, and then use an eraser to remove some of the color and create a glossy line.

Your Turn

> Quick Tip

If you layer a separate color (a dark intermediate or complementary color) on the drop's shading, it will look more three dimensional. Here, intermediate colors 115 and 190 have been used on the yellow drop's shading and complementary color 120 has been used on the red drop's shading, giving them both a three-dimensional effect.

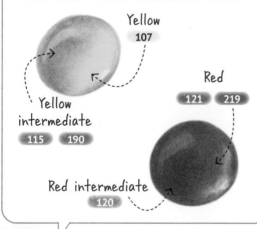

Yellow
`107`

Yellow intermediate
`115` `190`

Red
`121` `219`

Red intermediate
`120`

▶ A tear-out practice sheet can be found on page 101.

Expressing Differences in Texture—Part 1

GOAL **In this exercise, we'll practice expressing texture. Let's try drawing each different texture for ceramic, metal, glass and wood.**

Process and Key Points

Ceramic Cup

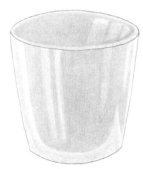

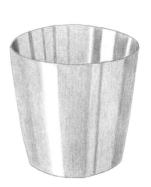

The smooth texture of the ceramic can be emulated by reducing the difference in brightness levels.

Color Needed

156
Cobalt
Green

1 Use 156 to color the entire area, while leaving the highlights uncolored.

2 Next, lightly color the shiny areas using 156 .

3 For the shading, thickly layer 156 to complete.

Metal Cup

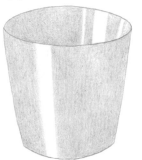

Adding clear light and dark shading to the surface creates a hard metal texture.

Colors Needed

274
Warm
Grey V

199
Black

1 Lightly color the entire area using 274 , while leaving the highlights uncolored.

2 Use 274 to add streaks to the dark areas.

3 To complete, use 199 to make the lines and shading darker inside the cup.

Glass Cup

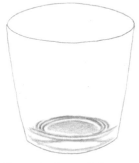

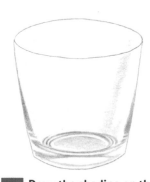

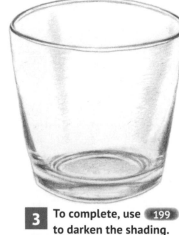

Where you want the thickness of the glass to be apparent, add crisply defined shading and leave the transparent areas white. Then, add very fine shading to create the impression of transparent glass.

Colors Needed

274
Warm
Grey V

199
Black

1 Draw the base of the glass using 274 .

2 Draw the shading on the sides by lightly coloring it with 274 .

3 To complete, use 199 to darken the shading.

Wooden Cup

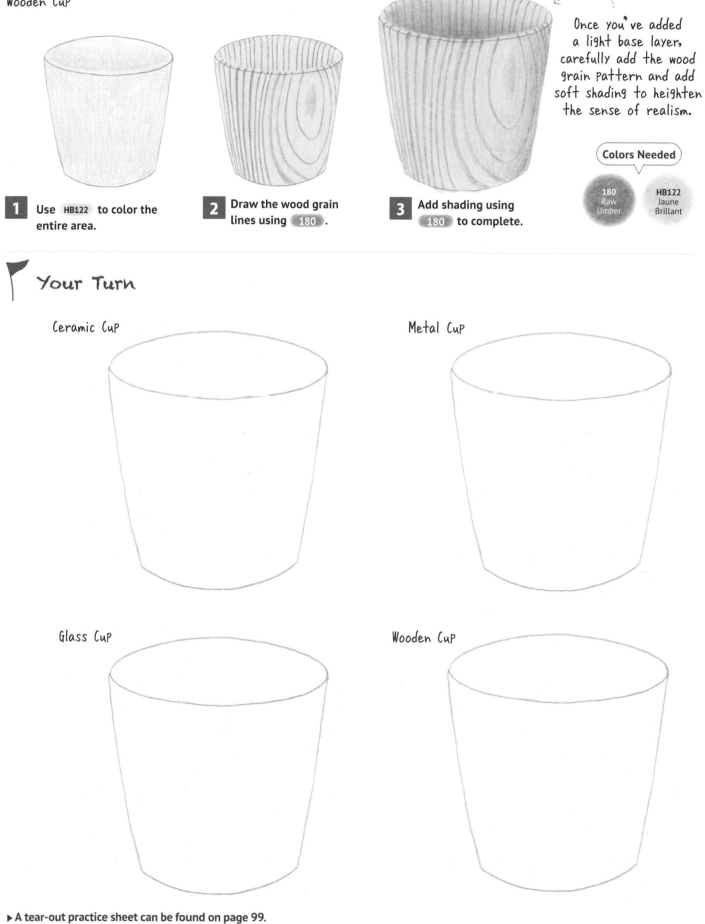

1 Use HB122 to color the entire area.

2 Draw the wood grain lines using 180.

3 Add shading using 180 to complete.

Once you've added a light base layer, carefully add the wood grain pattern and add soft shading to heighten the sense of realism.

Colors Needed

180 Raw Umber

HB122 Jaune Brillant

Your Turn

Ceramic Cup

Metal Cup

Glass Cup

Wooden Cup

▶ A tear-out practice sheet can be found on page 99.

Drawing a Metal Fork and Spoon

GOAL Let's try drawing a metal fork and spoon. To express the texture of cold metal, make sure to color it while creating variations in brightness between the light and dark areas. For a more realistic look, draw reflections of surrounding objects on the smooth mirror-like surfaces.

Example

Colors Needed

Fork

- 274 Warm Grey V
- 157 Dark Indigo
- 271 Warm Grey II
- 199 Black
- 140 Light Ultramarine

Shadow

- 153 Cobalt Turquoise
- 274 Warm Grey V

Spoon

- 274 Warm Grey V
- 157 Dark Indigo
- 271 Warm Grey II
- 199 Black
- 140 Light Ultramarine

Key Points for Drawing

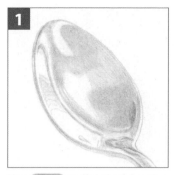

1

Use `274` to lightly color the entire area, while leaving the highlights uncolored.

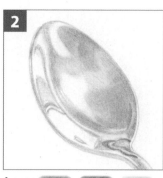

2

Layer `274`, `157`, `271` and `140` little by little to create shading.

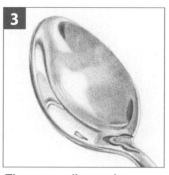

3

The surrounding environment is reflected, so for the darker-looking areas, layer `199` to add definition.

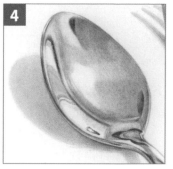

4

For the shadow cast on the table, use `153`, and then layer `274` —particularly in the dark areas—to finish.

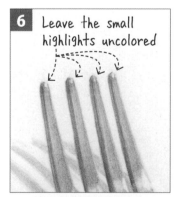

5

Color the fork in the same way. Very carefully color the shading on the sides to create a three-dimensional effect.

Your Turn

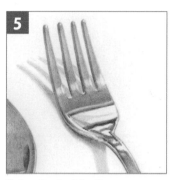

6

Leave the small highlights uncolored

Leaving small highlights at the tine tips gives the impression of sharpness.

> **Quick Tip**

Color the shadow on the table blue to make the silver sheen of the utensils pap and look beautiful!

▶ A tear-out practice sheet can be found on page 103.

Drawing a Glass Bottle

GOAL Here, we'll express the smooth surface of the clear glass and the way the light is reflected in the shadows that fall on the table. To create the effect of transparency, lay the colored pencil on its side and gently layer the color in light passes.

Example

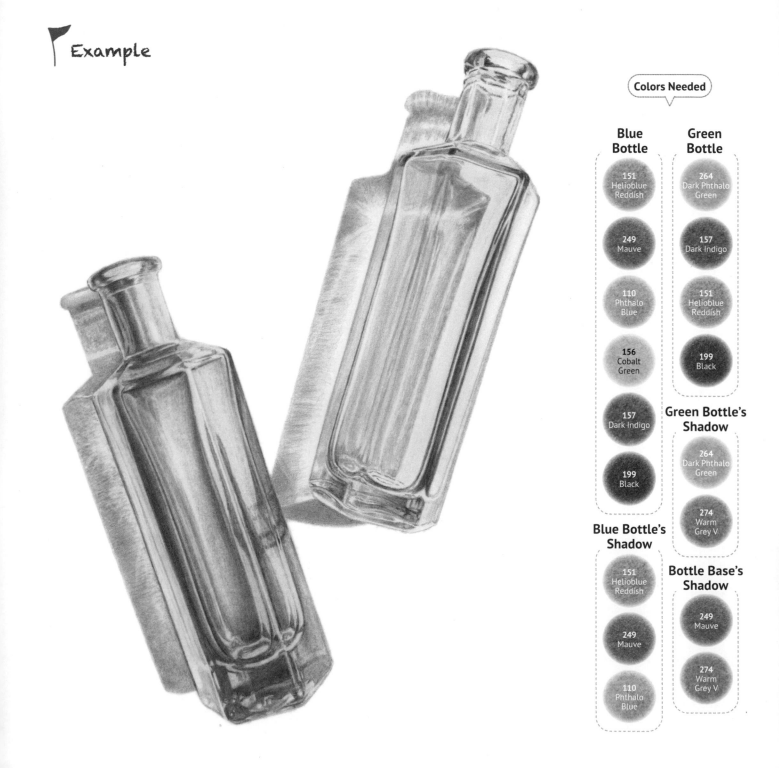

Colors Needed

Blue Bottle
- 151 Helioblue Reddish
- 249 Mauve
- 110 Phthalo Blue
- 156 Cobalt Green
- 157 Dark Indigo
- 199 Black

Green Bottle
- 264 Dark Phthalo Green
- 157 Dark Indigo
- 151 Helioblue Reddish
- 199 Black

Green Bottle's Shadow
- 264 Dark Phthalo Green
- 274 Warm Grey V

Blue Bottle's Shadow
- 151 Helioblue Reddish
- 249 Mauve
- 110 Phthalo Blue

Bottle Base's Shadow
- 249 Mauve
- 274 Warm Grey V

Process and Key Points

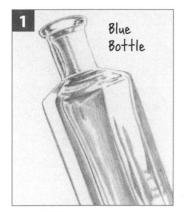

1 Blue Bottle

Use `151` to color the dark areas of the glass bottle. Layer the light colors gradually, paying attention to the transparency of the glass.

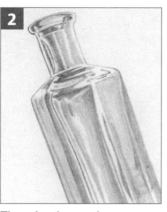

2

The color that can be seen reflected changes depending on the angle of the glass. Color lightly with `110`, `249` and `156`. For the dark areas, layer `157` and `199` to make them stand out.

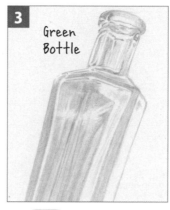

3 Green Bottle

Use `264` to color the dark areas of the glass bottle. Layer the light colors gradually, paying attention to the transparency of the glass.

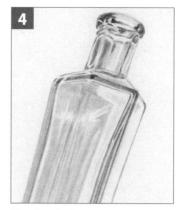

4

For the dark areas, layer `157`, `151` and `199` to make them stand out.

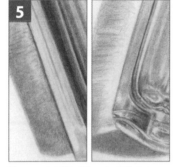

5

To create the blue bottle's shadow, lightly layer `110` on `151` and for the shadow of the bottle base, add an extra layer using `249`. For the green bottle's shadow, lightly layer `274` on `264` and near the bottom, layer `274` on `249`.

Your Turn

> ### Quick Tip
>
> You can emulate a smooth, glass-like surface by increasing the contrast between the shading of the bottle and the lightness of the highlights!

▶ A tear-out practice sheet can be found on page 103.

Drawing a Wooden Toy Car

GOAL Let's try drawing a toy car. The warm texture of the wood is expressed using warm colors. Closely observe the relationship between the light and shading, and then color it carefully. The aim is to create a beautiful finish for the wood grain.

❚ Example

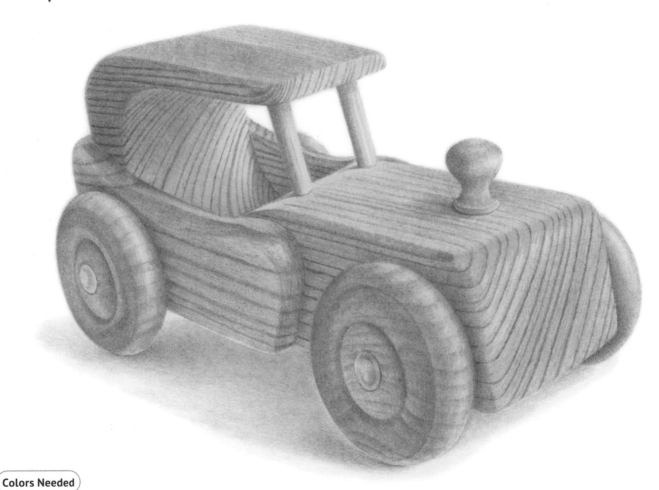

Colors Needed

Car

184 Dark Naples Ochre

111 Cadmium Orange

187 Burnt Ochre

109 Dark Chrome Yellow

115 Dark Cadmium Orange

177 Walnut Brown

Wood Grain

190 Venetian Red

180 Raw Umber

Shadow

274 Warm Grey V

Quick Tip

Don't make the wood grain lines unnaturally thick, or space them too widely. With rounded areas, either leave the highlights uncolored or remove the color with an eraser to make them softly shine!

Process and Key Points

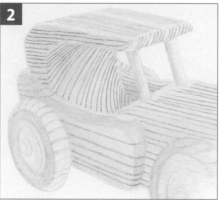

1

Lightly color using **184**, **111** and **187** to create a base layer, while adding a three-dimensional effect.

2

Use **190** to draw the wood grain lines. Be careful not to make them straight lines, and instead make them slightly wobbly, along with changing the thickness and density, and giving them uneven spacing.

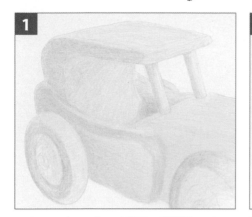

3

Use **184**, **111**, **187**, **109** and **115** to further add lightly colored layers and gradually create a darker color.

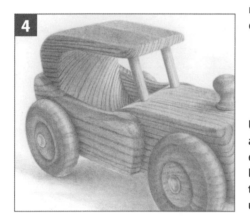

4

Use **190** and **180** to trace along the wood grain and create a darker color. For the car's shading, layer **177** and color the shadow that's cast on the surface below using **274**.

Your Turn

▶ A tear-out practice sheet can be found on page 105.

Expressing Differences in Texture—Part 2

GOAL Let's try imparting different textures to bread, cabbage leaves, droplets and fur.

Process and Key Points

French Bread

Colors Needed

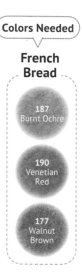

French Bread

1 Lightly color the entire area using 187.

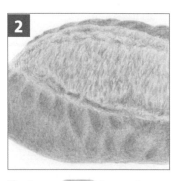

2 Next, use 187 to create a three-dimensional effect while drawing in the details.

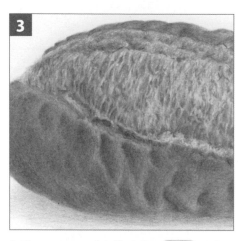

3 Add even more details using 187 and 190. To finish, use 177 for the more toasted areas.

187 Burnt Ochre

190 Venetian Red

177 Walnut Brown

Cabbage Leaf

Cabbage

1 Leave the leaf veins uncolored and use 112 to color the entire leaf. For the shadow under the thick leaf veins, use more 112 to make the color slightly darker.

2 Color the leaf veins using 102, and layer with 171.

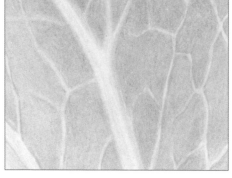

3 On the leafy areas, layer 168, 140 and 120 to create depth, and then the drawing is complete.

112 Leaf Green

102 Cream

171 Light Green

168 Earth Green Yellowish

140 Light Ultramarine

120 Ultramarine

Water Droplets

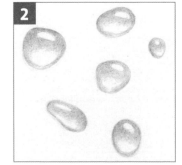

1 Color using 274 to create gradation, while leaving the highlights uncolored.

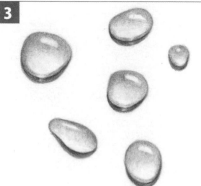

2 For the water droplet's shading, layer using 274 to create a three-dimensional effect.

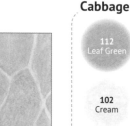

3 To finish, create the cast shadows that appear below the droplets using 199.

Water Droplets

274 Warm Grey V

199 Black

Fur

 1

Color and layer the entire area using , while staying aware of the flow of the hair.

 2

Use 180 and 177 to add shading.

 3

Express white hair by using HB422 and 140 to create shading.

Fur

187
Burnt Ochre

180
Raw Umber

177
Walnut Brown

HB422
Lilac

140
Light Ultramarine

Your Turn

French Bread

Cabbage Leaf

Water Droplets

Fur

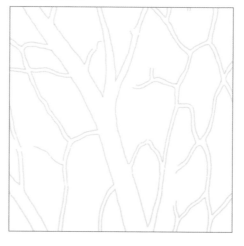

▶ A tear-out practice sheet can be found on page 99.

Drawing Chocolate Chip Cookies

GOAL Here we'll color delicious-looking chocolate chip cookies. Be sure to pay attention to the difference in texture between the baked cookie dough and the chocolate chips while drawing. Express the surface of the cookie by moving the pencil tip in short strokes to create an uneven appearance.

▶ Example

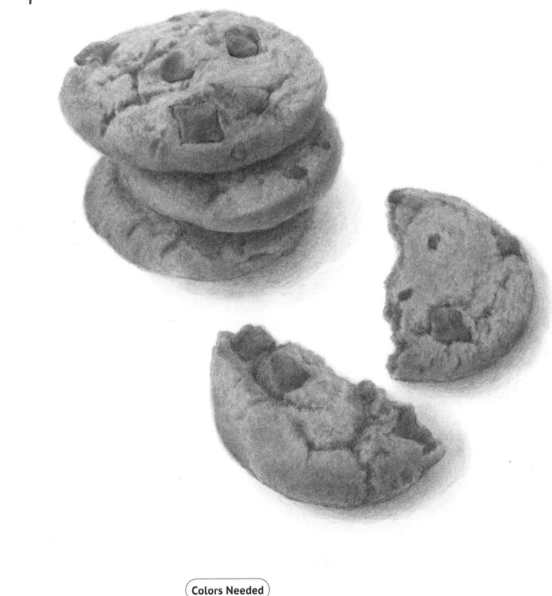

Colors Needed

Cookies

| 187 Burnt Ochre | 180 Raw Umber | 177 Walnut Brown | 190 Venetian Red |

Chocolate

| 190 Venetian Red | 177 Walnut Brown |

Shadow

| 274 Warm Grey V |

Process and Key Points

1 Lightly color the whole cookie using 187, while adding lines for cracks. For the chocolate chips, use 190, being careful to create a three-dimensional effect.

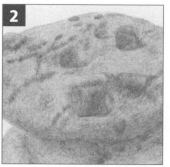

2 Keep gradually adding 180 to the crack lines and shading, building up three-dimensionality.

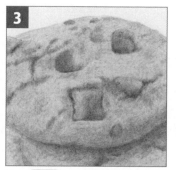

3 Use 177 to lightly color and layer the chocolate's shade as well as the crack lines that appear between the cookie and the chocolate chips.

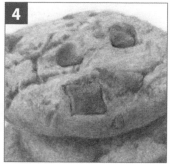

4 Use 187, 180 and 190 to lightly layer the whole cookie to create a more three-dimensional effect.

5 To complete, add a shadow using 274. If the subject is a dark color (as it is here with the baked cookie), color the shadow faintly to make the subject stand out.

Your Turn

> **Quick Tip**
>
> Where the cookies overlap each other and the edges where the chocolate chips have sunk into the cookie, apply pressure to the tip of the pencil and color strongly to create dark shading!

▶ A tear-out practice sheet can be found on page 105.

Drawing Asparagus

GOAL Asparagus is a familiar and easily available vegetable. Try drawing it while observing a real one. Being able to look closely at the swell of the scale leaves and using a dark color where the scale leaves overlap and for the deep shading in the gaps means you can achieve a much more three-dimensional effect.

▌ Example

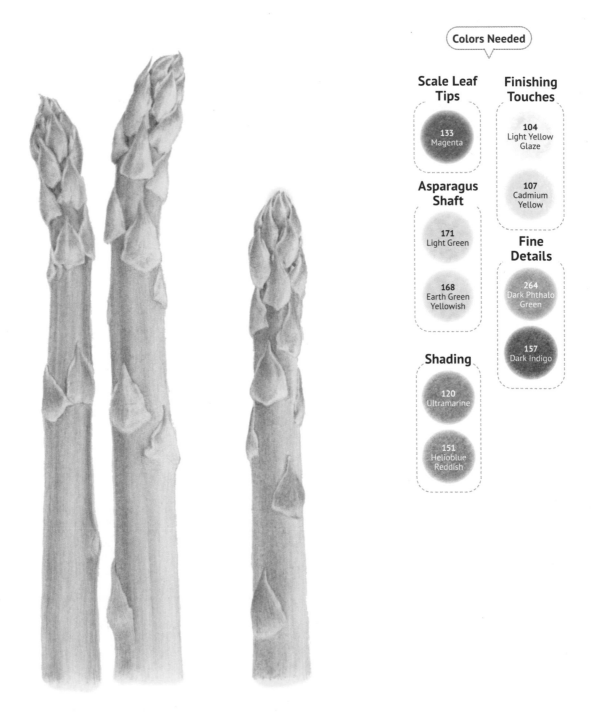

Colors Needed

Scale Leaf Tips

133 Magenta

Asparagus Shaft

171 Light Green

168 Earth Green Yellowish

Shading

120 Ultramarine

151 Helioblue Reddish

Finishing Touches

104 Light Yellow Glaze

107 Cadmium Yellow

Fine Details

264 Dark Phthalo Green

157 Dark Indigo

Process and Key Points

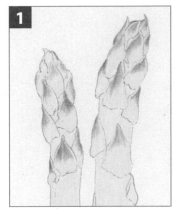

1

First, use `133` to color the tips of the scale leaves from top down, following the fibers and creating gradation as you go. Create a base layer for the whole area by lightly coloring with `171`.

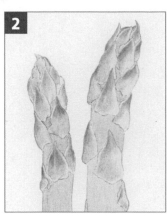

2

Next, lightly color the entire area using `168` and then add shading again using `168`, paying attention to the way the scale leaves swell, to create three-dimensionality.

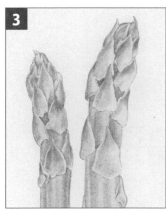

3

Layer `120` and `151` in the areas where shading appears.

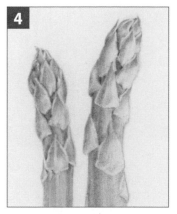

4

Layer `104` and `107` over the entire area. Adjust the details using `264` and color the darkest areas with `157` to bring the whole composition together.

Your Turn

> **Quick Tip**
>
> As you layer the colors, the colors that are added later don't have as much influence, so for the tips of the scale leaves, use `133` first and then add the green on top of that!

▶ A tear-out practice sheet can be found on page 107.

Drawing a Cocktail with Ice

GOAL Let's color an enticing club-soda cocktail in a clear glass. We'll draw the ice, bubbles and the curved base of the glass. Be sure to make the outline of the ice above the surface of the liquid sharp and the outline of the craggy ice below the surface slightly blurred.

Example

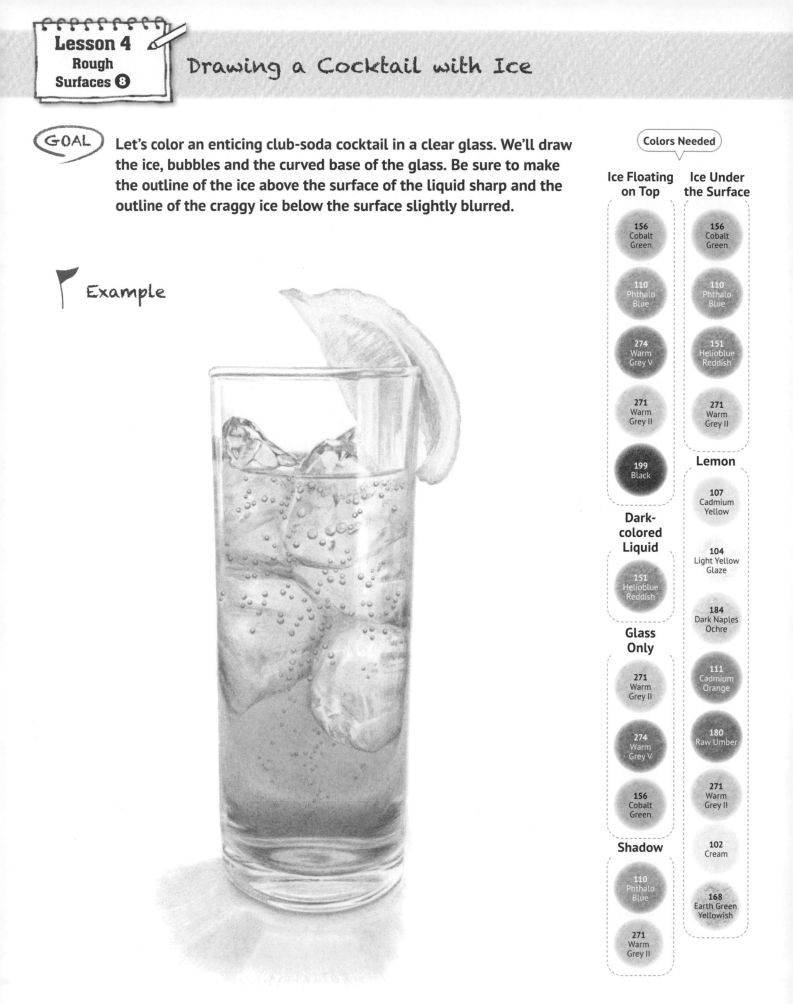

Colors Needed

Ice Floating on Top
- 156 Cobalt Green
- 110 Phthalo Blue
- 274 Warm Grey V
- 271 Warm Grey II
- 199 Black

Dark-colored Liquid
- 151 Helioblue Reddish

Glass Only
- 271 Warm Grey II
- 274 Warm Grey V
- 156 Cobalt Green

Shadow
- 110 Phthalo Blue
- 271 Warm Grey II

Ice Under the Surface
- 156 Cobalt Green
- 110 Phthalo Blue
- 151 Helioblue Reddish
- 271 Warm Grey II

Lemon
- 107 Cadmium Yellow
- 104 Light Yellow Glaze
- 184 Dark Naples Ochre
- 111 Cadmium Orange
- 180 Raw Umber
- 271 Warm Grey II
- 102 Cream
- 168 Earth Green Yellowish

⚐ Process and Key Points

Leave the highlight on the glass uncolored.

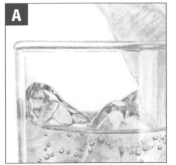

A

B

C

D

For the ice that rises above the surface of the liquid, the color of the reflection is different depending on the surface, so color using `156` and `110` . Use `274` , `271` and `199` for the shading.

For the ice in the liquid, color the reflections using `156` , `110` and `151` , and use `271` for the shading. To create the bubbles, use `156` to draw fine circles and use `110` to add shading to the bottom half of the liquid.

Use `151` for the dark liquid at the base of the glass and use the same color for the shading at the sides, making it darker. Add finishing touches to the area of glass where there is no liquid with `271` `274` `156` .

To create the shadow cast on the table by the liquid, color lightly with `110` , and then lightly color the shadow of the glass using `271` , making both form part of a radial pattern.

Leave the highlight on the glass uncolored.

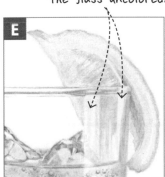

E

⚐ Your Turn

Use `107` for the lemon peel and create a base layer the inner fruit using `104` , and then use `184` and `111` to add shading. For the outline of the edge of the lemon and the shading inside the peel and on the fruit, lightly color using `180` . Then use `271` and `102` for the white part and `168` for the shading on the fruit to finish.

> Quick Tip

When drawing the circular air bubbles, make sure to have a sharp pencil tip and draw using a very fine line!

▶ **A tear-out practice sheet can be found on page 107.**

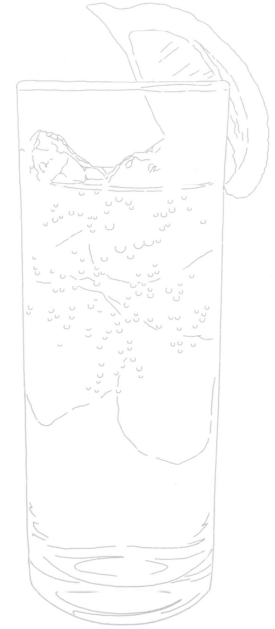

Drawing a Cocktail with Ice 51

Yoshiko Watanabe's Colored Pencil Picture Gallery #2: Delicious Desserts

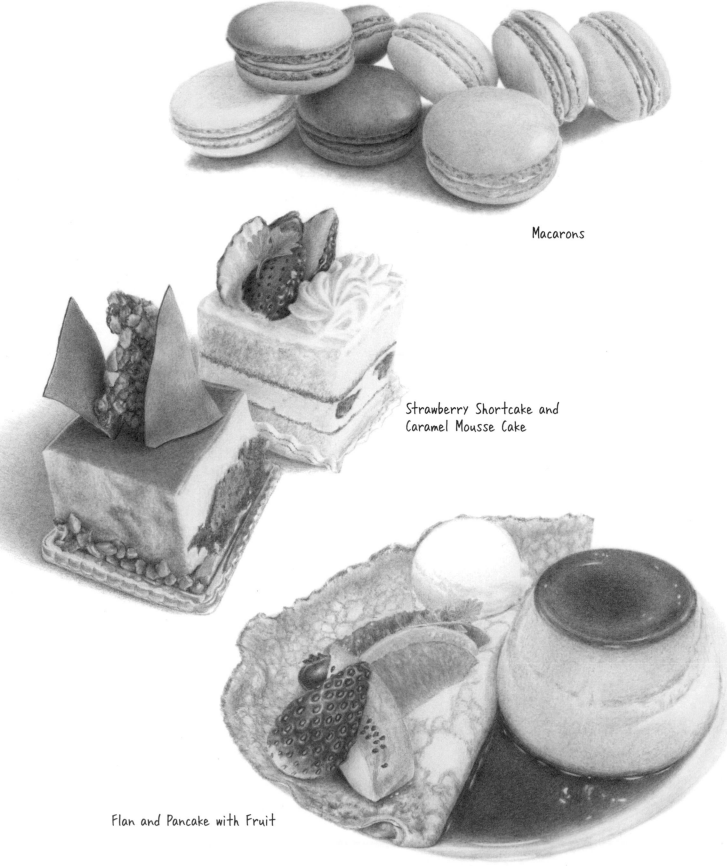

Macarons

Strawberry Shortcake and Caramel Mousse Cake

Flan and Pancake with Fruit

Part 3: Practical Lessons ✏️

Drawing Simple Subjects

Lesson 5: Foods (Melon / Berry Tart)

Here, we'll try drawing various subjects using what you've practiced so far. Let's start with food. We'll color it so it looks delicious.

Lesson 6: Plants (Hydrangea / Succulents)

Next, we'll try drawing flowers and plants.

Lesson 7: Household Items (Antique Handkerchief / Jars of Pickles)

Let's try drawing some small items that we find on hand around us.

Lesson 8: Animals (Parakeet / Kitten)

Here, we'll draw some adorable animals.

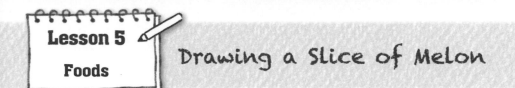

Drawing a Slice of Melon

GOAL Let's color a delicious-looking slice of melon. Carefully depict the juiciness of the ripe fruit and the characteristic pattern of the fibrous rind.

▛ Example

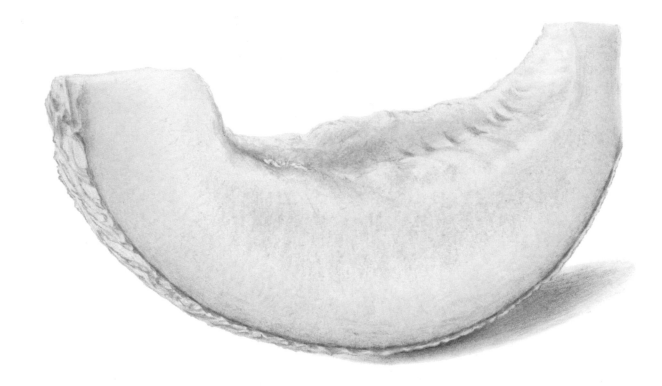

Colors Needed

Yellow Part of the Fruit

102 Cream	109 Dark Chrome Yellow	111 Cadmium Orange	184 Dark Naples Ochre	180 Raw Umber	HB122 Jaune Brillant

Rind / Webbing

HB122 Jaune Brillant	163 Emerald Green	180 Raw Umber	264 Dark Phthalo Green	157 Dark Indigo

Green Part of the Fruit

102 Cream	171 Light Green	168 Earth Green Yellowish	112 Leaf Green	120 Ultramarine	HB122 Jaune Brillant

Shading

271 Warm Grey II

Shadow

274 Warm Grey V

Process and Key Points

1

Color the entire fruit using 102 .

2

For the texture of the rind, use HB122 and lightly color the rind using 163 .

3

Where the fruit is mostly yellow, layer 109 , 111 and 184 to create a three-dimensional effect. Color the seed indentations using 180 .

4

Add 180 to the shading of the rind texture, and where the fruit is green, layer 171 , 168 , 112 and 120 . For the shading on the edges and within the fruit, layer 271 and color the rind cross-section using 264 .

5

For the fruit, use HB122 and lightly layer 184 , then for the dark areas of the rind cross-section, layer 157 . The shadow on the table uses 274 .

Your Turn

> **Quick Tip**
>
> Blur the gradation in color from the fruit to the rind with a cotton swab so that the transition is smooth, creating a natural look!

▶ A tear-out practice sheet can be found on page 109.

Drawing a Berry Tart

GOAL Here, let's color a scrumptious tart with a variety of berries on top. Try creating the different textures of the berries, the shiny translucent syrup, the custard filling and the tart pastry.

⚑ Example

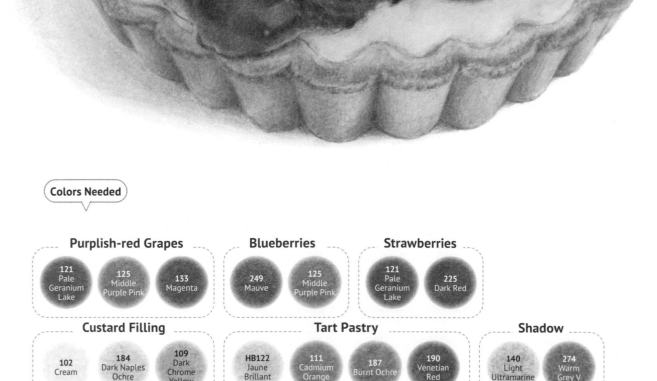

(Colors Needed)

Purplish-red Grapes

- 121 Pale Geranium Lake
- 125 Middle Purple Pink
- 133 Magenta

Blueberries

- 249 Mauve
- 125 Middle Purple Pink

Strawberries

- 121 Pale Geranium Lake
- 225 Dark Red

Custard Filling

- 102 Cream
- 184 Dark Naples Ochre
- 109 Dark Chrome Yellow

Tart Pastry

- HB122 Jaune Brillant
- 111 Cadmium Orange
- 187 Burnt Ochre
- 190 Venetian Red

Shadow

- 140 Light Ultramarine
- 274 Warm Grey V

Process and Key Points

1

For the purplish-red grapes, first use `121` to color the entire area, while leaving the highlight white. Add a small amount of shading to create a three-dimensional effect.

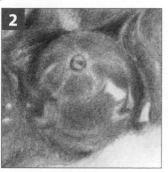

2

Next, with `125`, lightly layer the entire area, while still leaving the highlight uncolored, and then color the dark areas using `133` to finish.

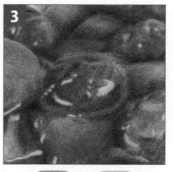

3

Layer `249` and `125` in that order for the blueberries. For the strawberries, color the entire area with `121` while creating a three-dimensional effect. Layer the dark areas with `225` to finish.

4

Create a base layer using `102` for the custard filling and layer `184` and `109` for the shading. For the tart pastry, lightly color using `HB122` to create a base layer. Next, layer `111`, and then finish by layering `187` and `190` for the shading.

Your Turn

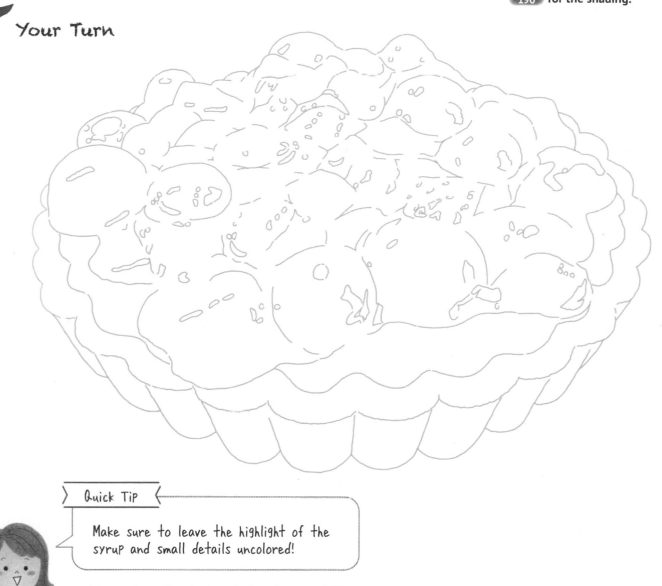

> Quick Tip
>
> Make sure to leave the highlight of the syrup and small details uncolored!

▸ A tear-out practice sheet can be found on page 109.

Drawing a Hydrangea

GOAL Combine bluish and reddish colors to create the purple of the hydrangea sepals. The purple can be more reddish or bluish in places, so try changing the proportions of each color used. Create the three-dimensional effect of the many overlapping sepals by expertly adding shading.

◤ Example

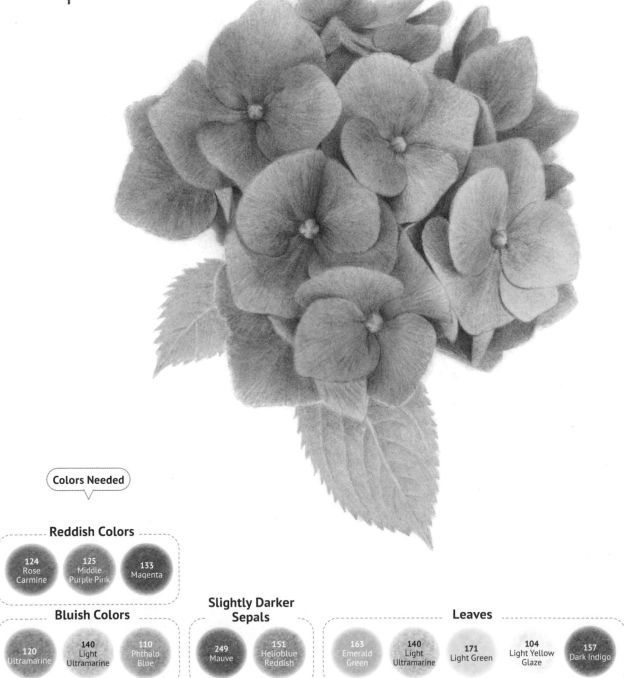

Colors Needed

Reddish Colors

- 124 Rose Carmine
- 125 Middle Purple Pink
- 133 Magenta

Bluish Colors

- 120 Ultramarine
- 140 Light Ultramarine
- 110 Phthalo Blue

Slightly Darker Sepals

- 249 Mauve
- 151 Helioblue Reddish

Leaves

- 163 Emerald Green
- 140 Light Ultramarine
- 171 Light Green
- 104 Light Yellow Glaze
- 157 Dark Indigo

⚑ Process and Key Points

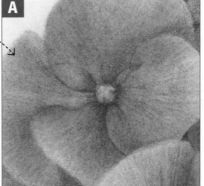

A

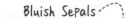
Bluish Sepals

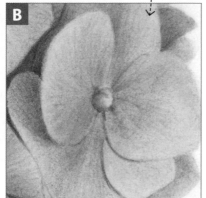

B

Slightly Darker Sepals

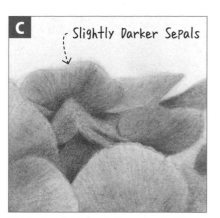

C

To create the purple of the hydrangea sepals, combine the reddish colors (124 , 125 and 133) and bluish colors (120 , 140 and 110). For the reddish sepals, increase the proportion used of those colors.

For the bluish sepals, increase the proportion of bluish colors used.

With the slightly darker sepals, first mix reddish and bluish colors, and then layer on 249 and 151 .

⚑ Your Turn

D

For the leaves, layer 140 and 171 on 163 , and then layer 104 on top to create a vivid hue. Layer more heavily near the edges of the leaf veins so they are slightly darker. For the shadow of the flowers, lightly color using 157 .

> **Quick Tip**
>
> Layer the colors of the hydrangea sepals from the center outward following the direction of the fibers. Even when combining the same colors, depending on how much or how little you layer them, you can create varied tones!

▸ **A tear-out practice sheet can be found on page 111.**

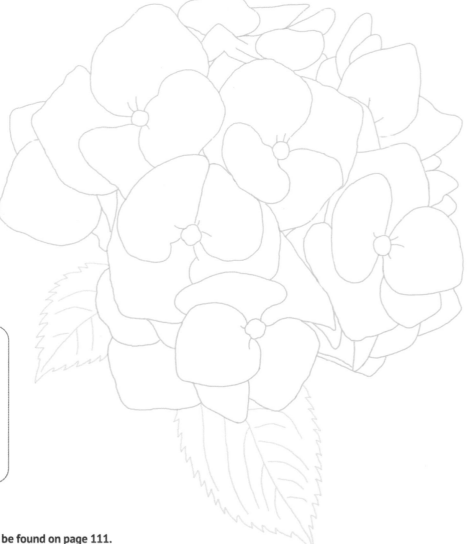

Drawing an Arrangement of Succulents

GOAL Let's color a collection of succulents, giving them lovely vibrant hues and plump-looking forms. Carefully create the unique texture of the fleshy leaves and the different colors and shapes of each type of plant.

▛ **Example**

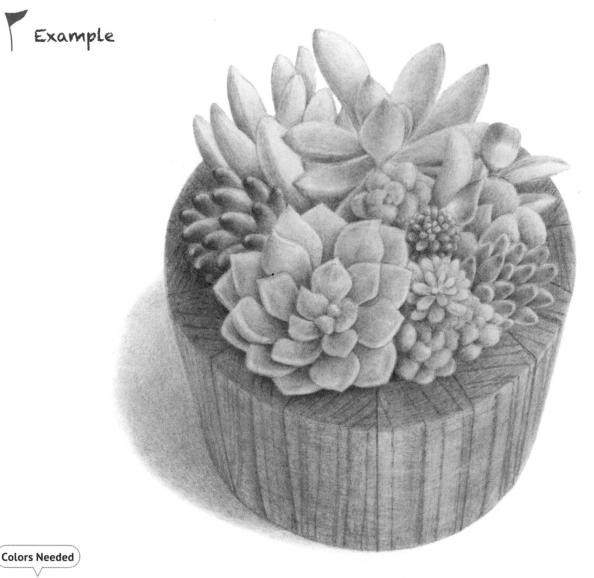

Colors Needed

Green Plants
- 112 Leaf Green
- 151 Helioblue Reddish
- 157 Dark Indigo

Yellow Plants
- 104 Light Yellow Glaze
- 171 Light Green
- 184 Dark Naples Ochre
- 187 Burnt Ochre

Reddish Plants
- 121 Pale Geranium Lake
- 225 Dark Red
- 171 Light Green
- 187 Burnt Ochre

Ochre Plants
- 187 Burnt Ochre
- 171 Light Green

Purple Plants
- 125 Middle Purple Pink

Container
- 177 Walnut Brown
- 180 Raw Umber

Shadow
- 274 Warm Grey V

Process and Key Points

For the green plants, lightly color using **112** , and use that same color for the shading, making it darker. Then, layer **151** on the darker areas and where it's darkest, use **157** .

For the yellow plants, use **104** to create a base layer. Then, from the base to halfway up, lightly color with **171** to create gradation. For the shading of the thick leaves, layer **184** and **187** .

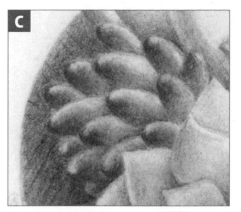

With the reddish plants, use **121** and **225** to create color gradation, while leaving the highlight uncolored. For the yellowish areas, use **171** to lightly color, and layer **187** to create the shading.

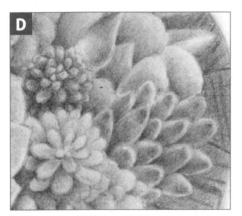

For the ochre plants, while coloring use **187** to create fine shading, and in the center area use **171** . Leave the edges of the purple plants uncolored and lightly color the rest of the area using **125** , making the tips and bases darker.

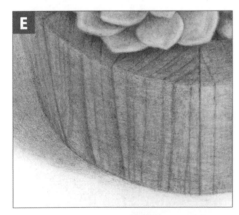

On the container, use **177** to draw the wood grain and use **177** with **180** in various places to lightly color the entire area. To finish, use **274** to create the shadow cast on the table.

Your Turn

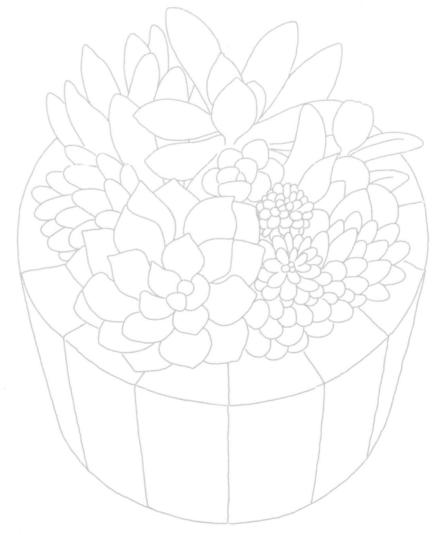

▶ A tear-out practice sheet can be found on page 111.

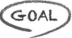
Drawing an Antique Handkerchief

GOAL Here, we'll draw in the color for a folded antique handkerchief. The white cloth is expressed by delicately adding light shading. Envision the soft texture of the cloth and the three-dimensionality of the embroidery thread while working.

🚩 Example

Colors Needed

Shading of White Cloth's Wrinkles

- HB422 Lilac
- 271 Warm Grey II

Embroidered Edging

- 109 Dark Chrome Yellow
- 219 Deep Scarlet Red

Shadow

- 271 Warm Grey II
- 274 Warm Grey V

Embroidered Red Flower
- 107 Cadmium Yellow
- 111 Cadmium Orange
- 115 Dark Cadmium Orange
- 217 Middle Cadmium Red
- 219 Deep Scarlet Red

Blue Butterfly
- 140 Light Ultramarine
- 151 Helioblue Reddish
- 107 Cadmium Yellow
- 187 Burnt Ochre
- 177 Walnut Brown

Embroidered Yellow Flowers
- 107 Cadmium Yellow
- 111 Cadmium Orange
- 115 Dark Cadmium Orange
- 219 Deep Scarlet Red
- 168 Earth Green Yellowish
- 264 Dark Phthalo Green

Green Flowers and Stems
- 168 Earth Green Yellowish
- 264 Dark Phthalo Green
- 151 Helioblue Reddish

Process and Key Points

A

B

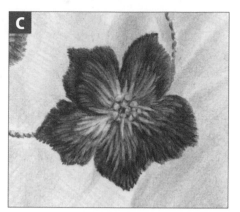

C

There are only subtle differences in the brightness of the shading for the wrinkles on the white cloth. Color very lightly using `HB422` and `271`, and progressively draw soft overlapping lines along the warp and weft of the cloth.

Where folds in the cloth appear, create distinctions with brightness and shading. Use gentle gradation to create subtle shading on the cloth. To create the embroidered blue butterfly, use `140`, `151`, `107`, `187` and `177`.

For the embroidered red flower, start with the light colors (`107`, `111` and `115`). Then, to create shade in the same area, layer the dark colors (`217` and `219`).

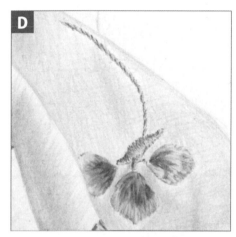

D

Color the embroidered yellow flowers using `107`, and then layer `111`, `115` and `219` for the dark thread. For the leaves, use `168` to color in a zigzag lines following the direction of the thread. Then, use `264` for the darker thread.

Your Turn

> **Quick Tip**
>
> To create the three-dimensional embroidered threads, carefully add shading to each thread, one by one!

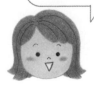

▶ A tear-out practice sheet can be found on page 113.

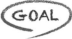

Lesson 7
Household Items

Drawing Jars of Pickles

GOAL Let's draw some pickled fruit in clear glass jars. Try drawing all the different textures of the smooth glass, the soft fruit and vegetables, and the hard metal lids.

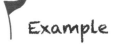

Example

Colors Needed

Lemon

107 Cadmium Yellow	109 Dark Chrome Yellow	111 Cadmium Orange	115 Dark Cadmium Orange	190 Venetian Red	102 Cream	HB122 Jaune Brillant

Orange Segment

109 Dark Chrome Yellow	187 Burnt Ochre

Blue Label

264 Dark Phthalo Green	151 Helioblue Reddish

Carrot

111 Cadmium Orange	115 Dark Cadmium Orange	133 Magenta	217 Middle Cadmium Red	107 Cadmium Yellow

Gold Lid

184 Dark Naples Ochre	180 Raw Umber	177 Walnut Brown

Silver Lid

274 Warm Grey V	199 Black	107 Cadmium Yellow

⚐ Process and Key Points

Carrot⟶ Orange Leave uncolored. Lighten with an eraser.

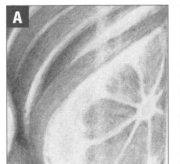 **A**

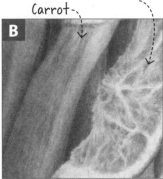 **B**

 C

 D

For the rind of the lemon, use `107` to create a base layer, and then layer with `109` and add `111` and `115` for lighter and darker areas. Finish with `190` for the shading. With the lemon slices, use `102` for the white areas and then layer shading with `HB122`.

For the carrot, use `111` and `115` for the base, and layer `133` and `217` to create shading. In brighter areas, layer `107` on top. Color the orange segment with `109` and `187`.

To create the highlight of the glass jar, leave the paper white. For the side of the jars, color the contents and then use an eraser to express soft reflectivity.

Use `184`, `180` and `177` for the gold lid. Finish with `264` and `151` for the blue label.

 E

For the silver lid, color using `274` and `199`. Create the reflected lemon-colored light by using `107` to color lightly.

⚐ **Your Turn**

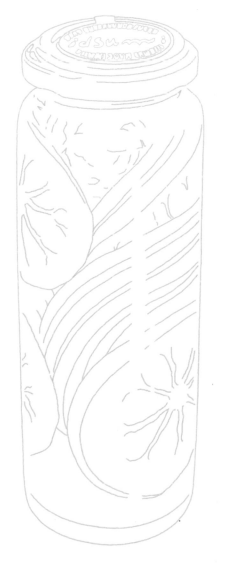

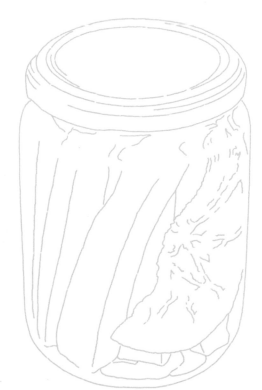

> Quick Tip ⟨

If you carefully control the pressure you use on the tip of the pencil when drawing the lemon slices and orange segment, you can express the texture realistically!

▶ A tear-out practice sheet can be found on page 113.

Drawing a Parakeet

GOAL Here, we'll color a parakeet with an impressive and bright wing pattern. The body is covered in fine feathers, so pay attention to their direction as you color. Rather than coloring the black pattern all at once, lightly layer it so it gradually becomes darker.

▌ Example

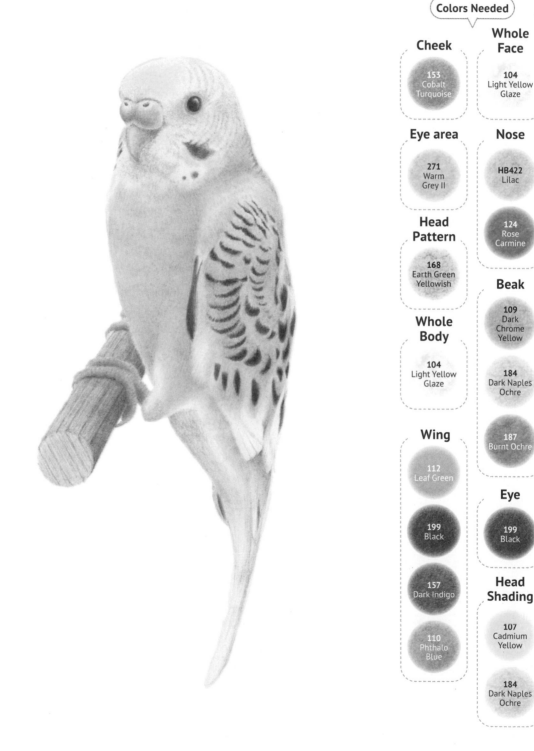

Colors Needed

Cheek
153
Cobalt
Turquoise

Whole Face
104
Light Yellow
Glaze

Eye area
271
Warm
Grey II

Nose
HB422
Lilac

124
Rose
Carmine

Head Pattern
168
Earth Green
Yellowish

Beak
109
Dark
Chrome
Yellow

184
Dark Naples
Ochre

187
Burnt Ochre

Whole Body
104
Light Yellow
Glaze

Wing
112
Leaf Green

199
Black

157
Dark Indigo

110
Phthalo
Blue

Eye
199
Black

Head Shading
107
Cadmium
Yellow

184
Dark Naples
Ochre

Perch
271
Warm
Grey II

HB122
Jaune
Brillant

180
Raw Umber

Legs and Talons
HB122
Jaune
Brillant

HB422
Lilac

124
Rose
Carmine

271
Warm
Grey II

Process and Key Points

1

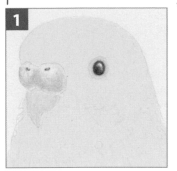

Color the whole head using 104 , and then use HB422 for the nose, followed by lightly coloring the beak with 109 . Color the eye using 199 , leaving the highlight area uncolored.

2

Lightly color the whole body using 104 , and finely layer 112 to create the three-dimensional look of the wing.

3

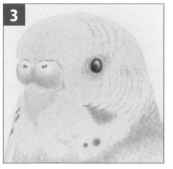

Color the shading on the head using 107 and 184 to create a three-dimensional effect, and use 153 for the cheek pattern. Add 124 for the shading of the nose.

4

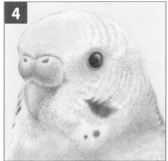

For the beak, layer 184 and 187 , and lightly color around the eyes using 271 . Draw the pattern on the head with 168 .

5

Use 199 to color the wing pattern, and layer with 157 too.

6

For the dark areas of the entire wing, use 110 to draw in short, fine lines that run along the down to create the texture of the feathers.

7

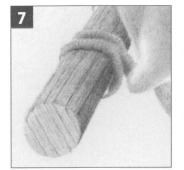

For the legs, layer HB122 , HB422 and 124 while adjusting the color, and then use 271 to color the talons. Use 271 to create a light base for the perch's wood, and then lightly layer HB122 , followed by 180 to darken the color. Draw the wood grain using 180 .

Your Turn

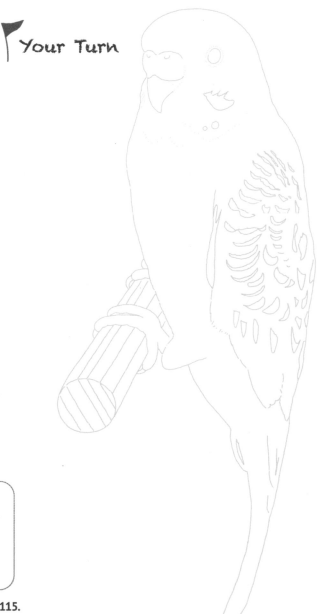

Quick Tip

Be careful when adding light colors like 104 , 112 and 110 after coloring the black pattern of the feathers, as those colors can get smudged!

▶ A tear-out practice sheet can be found on page 115.

Drawing a Kitten

GOAL Now, let's drawing in the color for a kitten. Carefully color the soft fur with its faint striped pattern. What's key here is to lay the pencil tip so that it moves in the direction of the flow of the fur. The subtle tints in the pupils are created by erasing part of the color there.

Example

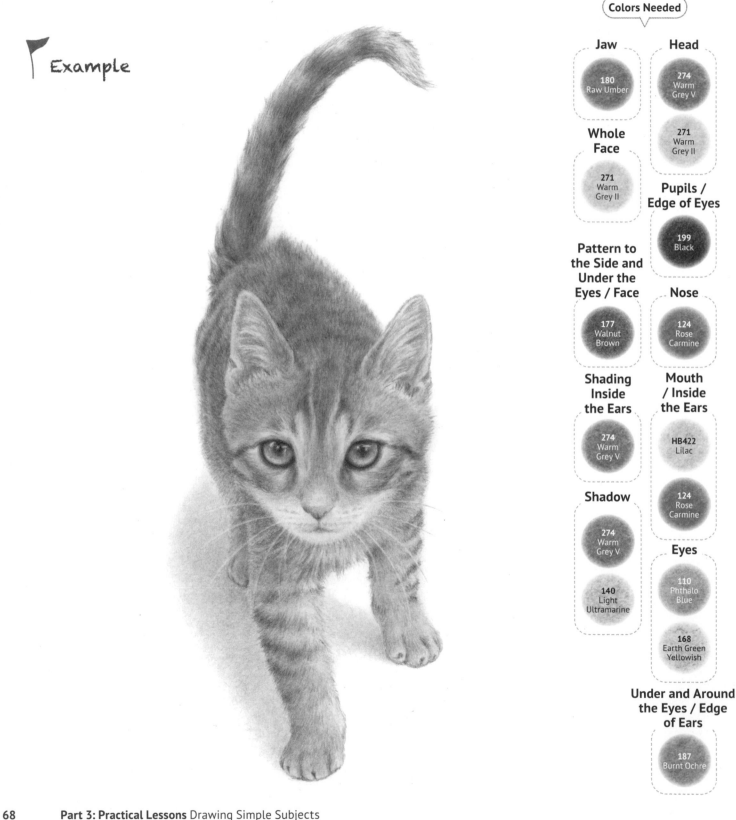

Colors Needed

Jaw
180
Raw Umber

Head
274
Warm Grey V

271
Warm Grey II

Whole Face
271
Warm Grey II

Pupils / Edge of Eyes
199
Black

Pattern to the Side and Under the Eyes / Face
177
Walnut Brown

Nose
124
Rose Carmine

Shading Inside the Ears
274
Warm Grey V

Mouth / Inside the Ears
HB422
Lilac

124
Rose Carmine

Shadow
274
Warm Grey V

140
Light Ultramarine

Eyes
110
Phthalo Blue

168
Earth Green Yellowish

Under and Around the Eyes / Edge of Ears
187
Burnt Ochre

Process and Key Points

Your Turn

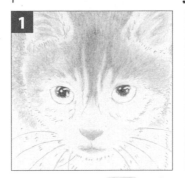

For the head, use 271 **and** 274 **. And for the pupils, use** 199 **while leaving the highlights uncolored. Use** 124 **for the nose and lightly color the mouth and inside the ears using** HB422 **and** 124 **.**

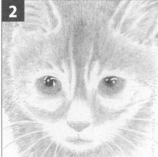

Color the eyes using 110 **and layer with** 168 **. Use** 187 **around and under the eyes as well as the edges of the ears. Color under the jaw with** 180 **.**

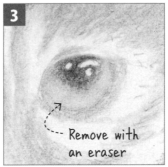

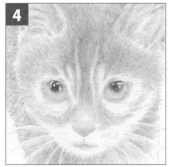

→ Remove with an eraser

Use an eraser to make the color in the lower half of the eyes fainter and round the eyes.

Avoiding the area around the eyes, mouth and the whiskers, color the face using 271 **.**

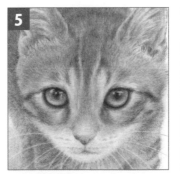

Color the edges of the eyes using 199 **. Create the pattern to the side and under the eyes with** 177 **and layer around the face too, avoiding the whiskers. Use** 274 **inside the ears for the shading.**

Create the shadow under the kitten using 274 **and** 140 **.**

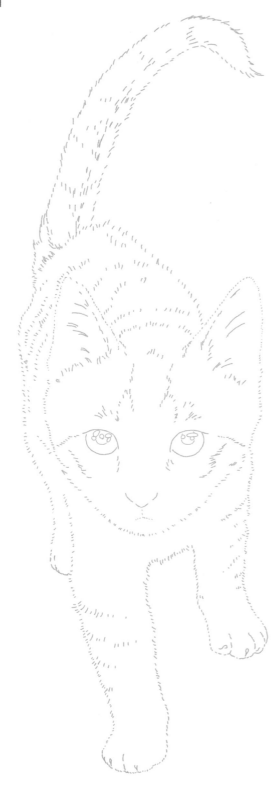

> Quick Tip <

Color the fur using light colors first, and then use darker colors to add short hairs and the pattern in small increments!

▶ **A tear-out practice sheet can be found on page 115.**

Yoshiko Watanabe's Colored Pencil Picture Gallery #3: Cute Animals

Welsh Corgi

Horse

Rosy-faced Lovebird

Part 4: Challenge Yourself

Drawing Complex Subjects

Lesson 9: Flowers (A Bouquet of Flowers)
Here, we'll carefully color an abundance of individual flower petals.

Lesson 10: Gemstones (Five Types of Gems)
In this lesson, we'll depict the sparkle of five differently colored gems.

Lesson 11: Breakfast (A Platter of Breakfast Foods)
Try depicting all of the colorful ingredients.

Lesson 12: Lunch (A Croquette Sandwich)
Try drawing a variety of ingredients with different textures.

Lesson 13: Dog (A Pomeranian)
Here, we'll learn how to express fluffy animal fur.

Lesson 14: Doll (An Antique Doll)
Learn how to carefully depict a doll's facial expression.

Drawing a Bouquet of Flowers

GOAL Here, we'll color an adorable bouquet of roses and carnations. Carefully color the overlapping petals by adding detailed shading.

Key Points for Drawing

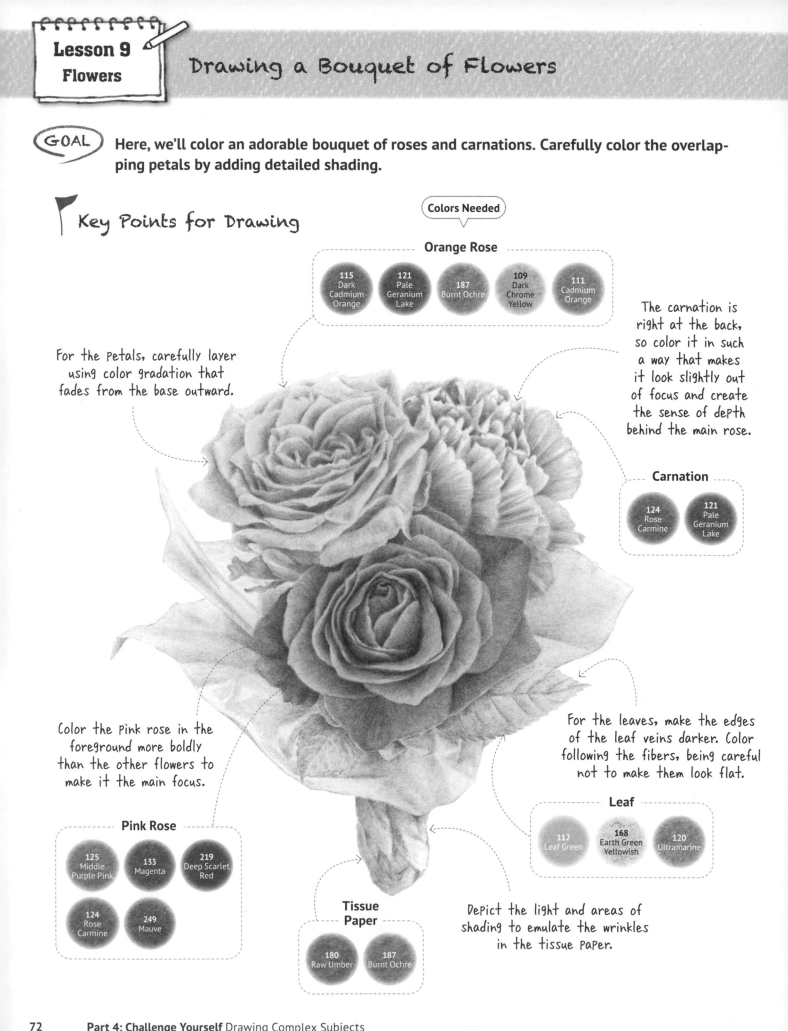

Colors Needed

Orange Rose

| 115 Dark Cadmium Orange | 121 Pale Geranium Lake | 187 Burnt Ochre | 109 Dark Chrome Yellow | 111 Cadmium Orange |

For the petals, carefully layer using color gradation that fades from the base outward.

The carnation is right at the back, so color it in such a way that makes it look slightly out of focus and create the sense of depth behind the main rose.

Carnation

| 124 Rose Carmine | 121 Pale Geranium Lake |

Color the pink rose in the foreground more boldly than the other flowers to make it the main focus.

For the leaves, make the edges of the leaf veins darker. Color following the fibers, being careful not to make them look flat.

Leaf

| 112 Leaf Green | 168 Earth Green Yellowish | 120 Ultramarine |

Pink Rose

| 125 Middle Purple Pink | 133 Magenta | 219 Deep Scarlet Red |
| 124 Rose Carmine | 249 Mauve | |

Tissue Paper

| 180 Raw Umber | 187 Burnt Ochre |

Depict the light and areas of shading to emulate the wrinkles in the tissue paper.

Process and Key Points

Color outward from the base of the petals using gradation.

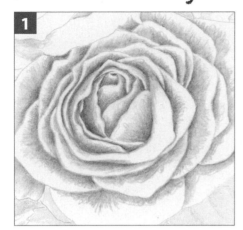

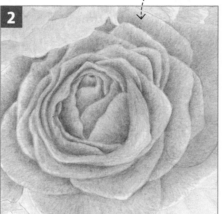

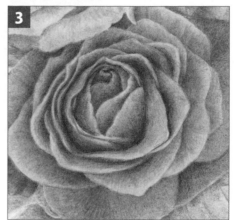

For the pink rose, start by using `125` for the shading where the petals overlap and the dark areas inside the flower.

Next, use `125` to create color gradation that gets lighter toward the edges of the petals. In certain places at the edges, leave small parts uncolored.

For the darker areas, use `133` to layer on more color. There are differences in color depending on the petal, so layer using `219`, `124` and `249` to create those variations.

Drawing the Orange Rose, Carnation, Leaves and Tissue Paper

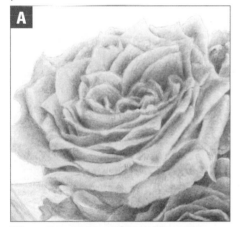

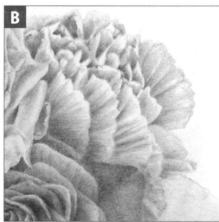

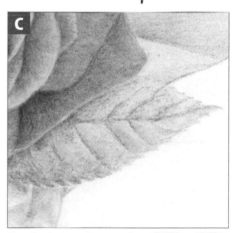

Where the petals overlap on the orange rose, use `115`, `121` and `187` (depending on the location) to color and create nuances in the shading. Next, lightly color using `109` and `111` to create gradation from the base of the petals outward.

For the carnation, lightly color out from the base of the petals with `124`, while creating gradation, and finish by layering `121` in the dark areas.

For the leaves, layer using `112`, `168` and `120`, following the pattern. Color while making the edges of the leaf veins darker, being careful not to make them look two-dimensional.

For the tissue paper, lightly color and layer using `180` and `187` to finish. Add shading to the wrinkles using `180` to create a crinkly texture.

> Quick Tip

Pay attention to the light texture of the petals, and be careful not to make areas outside of the shadows too dark!

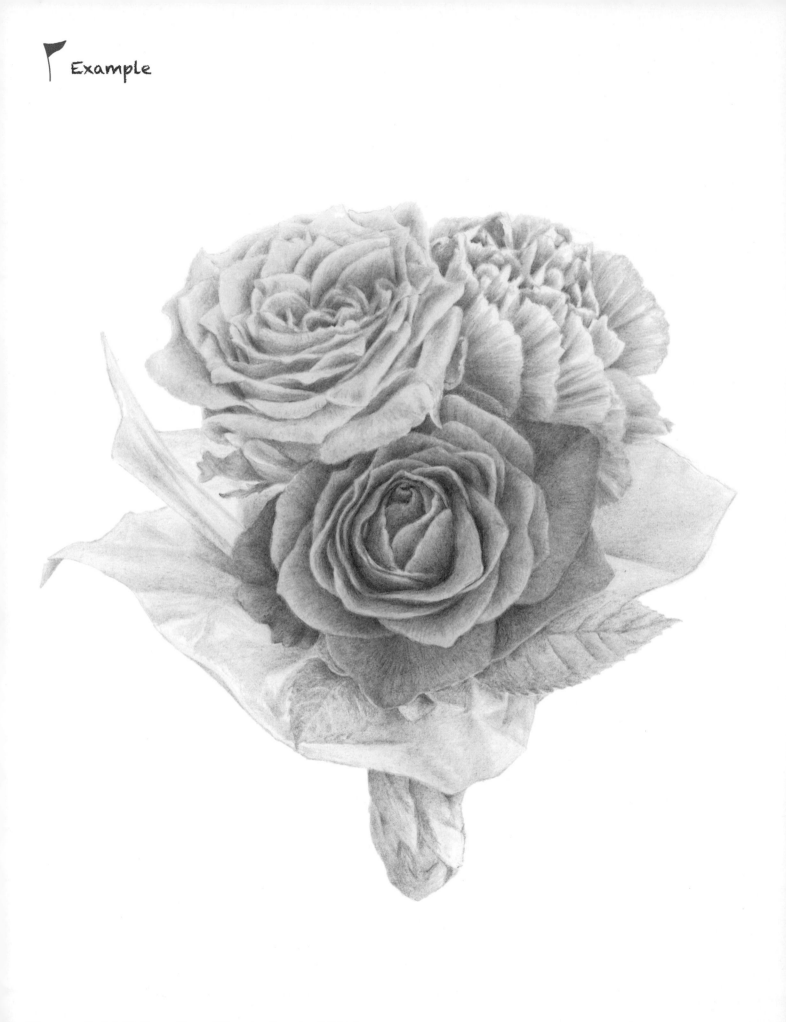

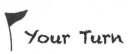

▶ **A tear-out practice sheet can be found on page 117.**

Lesson 10
Gemstones

Drawing Five Types of Gems

GOAL Let's color a range of sparkling gems, depicting amber, clear, emerald green, blue and pink stones. Using delicate gradation, try to emulate the brilliance and transparency of the gems. Also, be aware of how the reflection of the gem colors appear in the shadows on the table.

Key Points for Drawing

With each gem, pay attention to how the colors of the stones around it reflect in the facets.

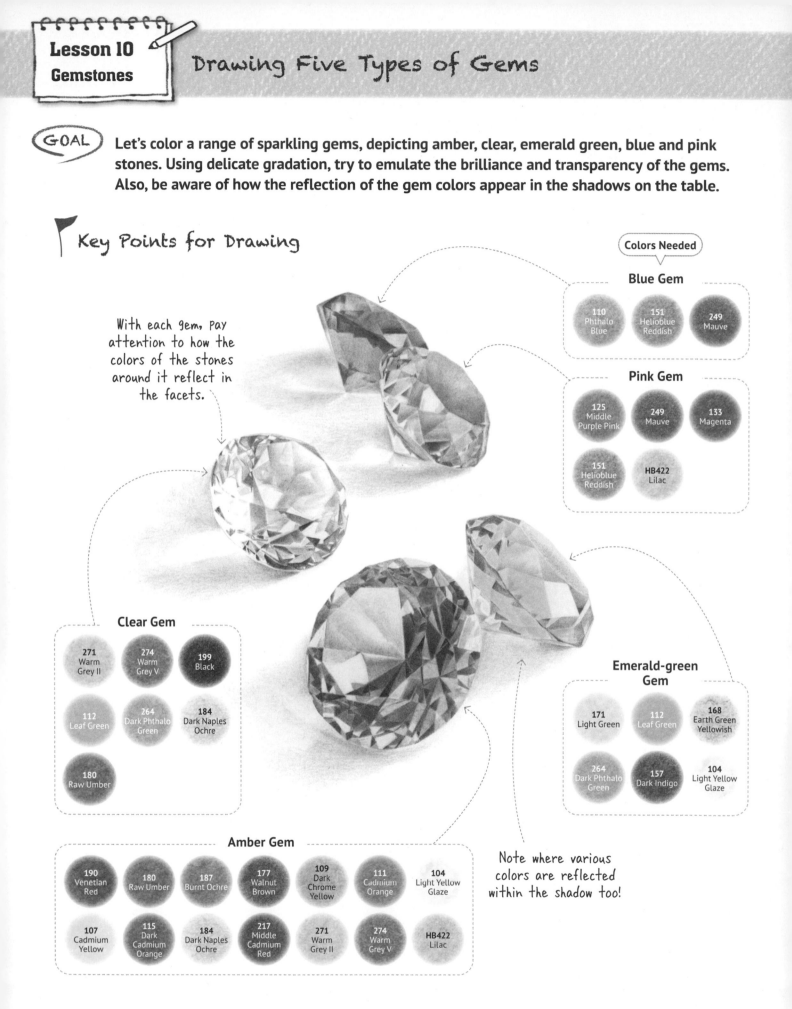

Colors Needed

Blue Gem
- 110 Phthalo Blue
- 151 Helioblue Reddish
- 249 Mauve

Pink Gem
- 125 Middle Purple Pink
- 249 Mauve
- 133 Magenta
- 151 Helioblue Reddish
- HB422 Lilac

Clear Gem
- 271 Warm Grey II
- 274 Warm Grey V
- 199 Black
- 112 Leaf Green
- 264 Dark Phthalo Green
- 184 Dark Naples Ochre
- 180 Raw Umber

Emerald-green Gem
- 171 Light Green
- 112 Leaf Green
- 168 Earth Green Yellowish
- 264 Dark Phthalo Green
- 157 Dark Indigo
- 104 Light Yellow Glaze

Note where various colors are reflected within the shadow too!

Amber Gem
- 190 Venetian Red
- 180 Raw Umber
- 187 Burnt Ochre
- 177 Walnut Brown
- 109 Dark Chrome Yellow
- 111 Cadmium Orange
- 104 Light Yellow Glaze
- 107 Cadmium Yellow
- 115 Dark Cadmium Orange
- 184 Dark Naples Ochre
- 217 Middle Cadmium Red
- 271 Warm Grey II
- 274 Warm Grey V
- HB422 Lilac

Process and Key Points for the Amber Gem

1

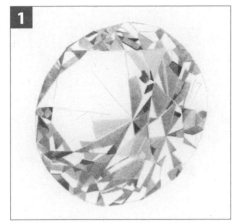

For the amber gem, start from where the color is darkest, using `190`, `180`, `187` and `177`. Next, color with `109` and `111` in the slightly lighter areas.

2

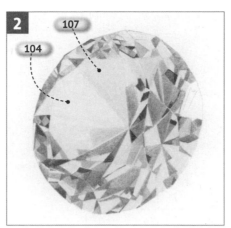

107
104

Color the rest of the area using `104` and layer `107` in the slightly darker areas.

3

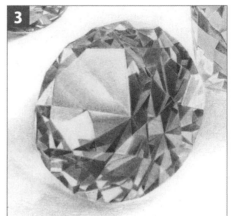

On each facet, gradually layer color using `115`, `184`, `217`, `271`, `274` and `HB422` while adjusting the shading.

Key Points for Drawing the Clear, Green, Blue and Pink Gems

A

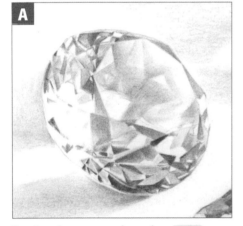

For the clear gem, color using `271`, `274` and `199` while leaving the sparkling areas uncolored. Carefully observe the shading of the adjacent facets while drawing each one. Use `112`, `264`, `184` and `180` to add the reflected colors of the amber and emerald-green gems too.

B

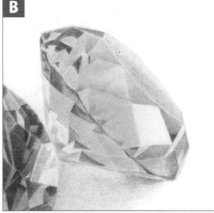

With the emerald-green gem, there are various green tones that appear depending on the facet, so create them by layering `171`, `112`, `168` and `264`. In particularly dark areas layer `157`. Use `104` to add the reflected color of the amber gem.

C

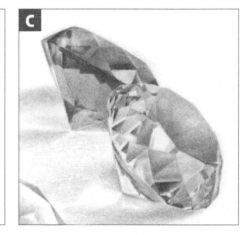

Color the blue gem using `110`, `151` and `249`, and color the pink gem with `125`, `249`, `133`, `151` and `HB422` to finish. For the light-colored gems, add very light gradation while taking care not to allow the color to get too dark.

> Quick Tip

Patiently color one facet at a time like they are mosaic tiles, identifying the difference in color and shade from light, through medium, to dark.

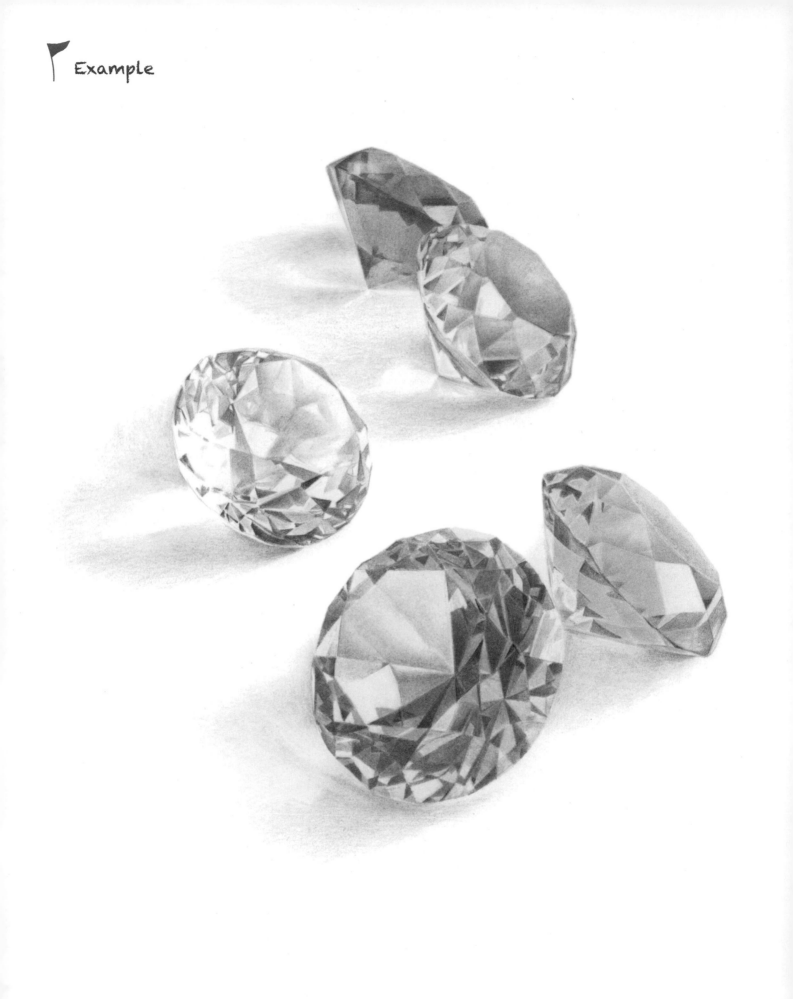

▶ A tear-out practice sheet can be found on page 119.

Drawing a Platter of Breakfast Foods

GOAL — Perfectly toasted bread topped with cream cheese and strawberry jam. Corn soup, fried egg, a vibrant salad... Let's color an appetizing breakfast platter. Depict the textures of all the various food items so they look delicious.

Key Points for Drawing

Colors Needed

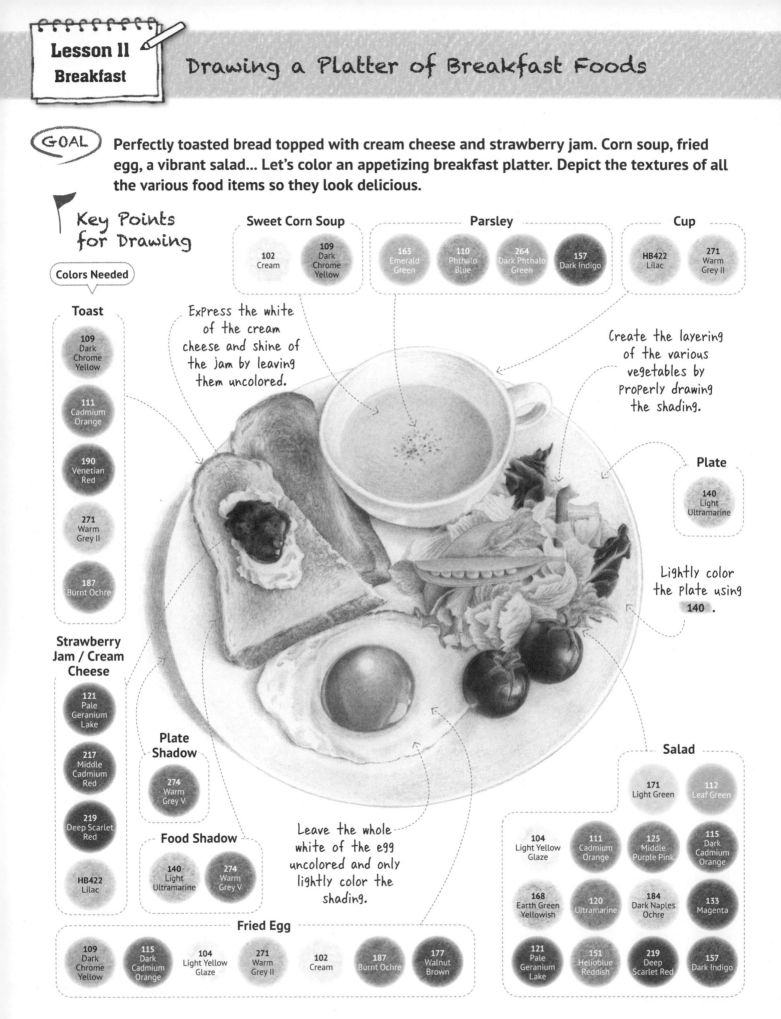

Sweet Corn Soup
- 102 Cream
- 109 Dark Chrome Yellow

Parsley
- 163 Emerald Green
- 110 Phthalo Blue
- 264 Dark Phthalo Green
- 157 Dark Indigo

Cup
- HB422 Lilac
- 271 Warm Grey II

Toast
- 109 Dark Chrome Yellow
- 111 Cadmium Orange
- 190 Venetian Red
- 271 Warm Grey II
- 187 Burnt Ochre

Strawberry Jam / Cream Cheese
- 121 Pale Geranium Lake
- 217 Middle Cadmium Red
- 219 Deep Scarlet Red
- HB422 Lilac

Plate Shadow
- 274 Warm Grey V.

Food Shadow
- 140 Light Ultramarine
- 274 Warm Grey V

Plate
- 140 Light Ultramarine

Salad
- 171 Light Green
- 112 Leaf Green
- 104 Light Yellow Glaze
- 111 Cadmium Orange
- 125 Middle Purple Pink
- 115 Dark Cadmium Orange
- 168 Earth Green Yellowish
- 120 Ultramarine
- 184 Dark Naples Ochre
- 133 Magenta
- 121 Pale Geranium Lake
- 151 Helioblue Reddish
- 219 Deep Scarlet Red
- 157 Dark Indigo

Fried Egg
- 109 Dark Chrome Yellow
- 115 Dark Cadmium Orange
- 104 Light Yellow Glaze
- 271 Warm Grey II
- 102 Cream
- 187 Burnt Ochre
- 177 Walnut Brown

Express the white of the cream cheese and shine of the jam by leaving them uncolored.

Create the layering of the various vegetables by properly drawing the shading.

Lightly color the plate using 140.

Leave the whole white of the egg uncolored and only lightly color the shading.

Key Points for Drawing the Toast, Strawberry Jam, Corn Soup and Fried Egg

Leave this highlight uncolored.　Lightly tint this highlight.

A

B

C

For the toast, use `109` and `111` to add rough touches to the surface and draw the darkly toasted areas with `190`. The cracks in the bread are created using `271` and the crust uses `187`. Color the entire area of the strawberry jam with `121`, leaving the shiny parts uncolored, and then use `217` and `219` for the dark areas. To express the cream cheese, allow the white of the paper to stand alone, and add shading using `HB422`.

With the corn soup, use `102` to color the whole area solidly and add shading with `109`. Draw in the parsley as specks using `163`, `110`, `264` and `157`. Create a three-dimensional effect for the soup cup by using `HB422` and `271` for the shading.

Color the fried egg with `109` and `115`, and then layer with `104`. By making the top part of the yolk bright and the sides dark, it creates three-dimensionality. Leave the round highlight on top of the yolk uncolored, and lightly color the shine on the side. For the egg white, add `271` and `102` in places to finish. To create the dark fried edges, use `187` and `177`.

Process and Key Points for the Salad

1

2

3

Lightly color a base layer over the entire area while adding a certain amount of shading. For the bright areas of the lettuce and other green vegetables, use `171`, and for the dark areas, use `112`. Color the yellow pepper with `104`, and the red pepper using `111`. To create the red cabbage, use `125` while avoiding the veins, and color the tomato with `115`, leaving the highlight uncolored. Create the tomato stem using `168`.

Add shading, gradually coloring the whole area darker. For the shading of the lettuce and other green vegetables, use `120` and `168`. Use `184` for the yellow pepper's shading, and use `115` for the red pepper's shading. Color the red cabbage shading with `133`, the tomato's with `121`, and the tomato stem's with `151`.

Use `120` to draw the veins and crinkles little by little on the lettuce and other green leafy vegetables. To finish shading the tomato, use `219`. Color the stem again using `168`, and layer `157` to create a three-dimensional shading effect.

> Quick Tip

Take your time with the colorful vegetables in the salad, paying attention to how they overlap and their shading, as well as the different textures they have!

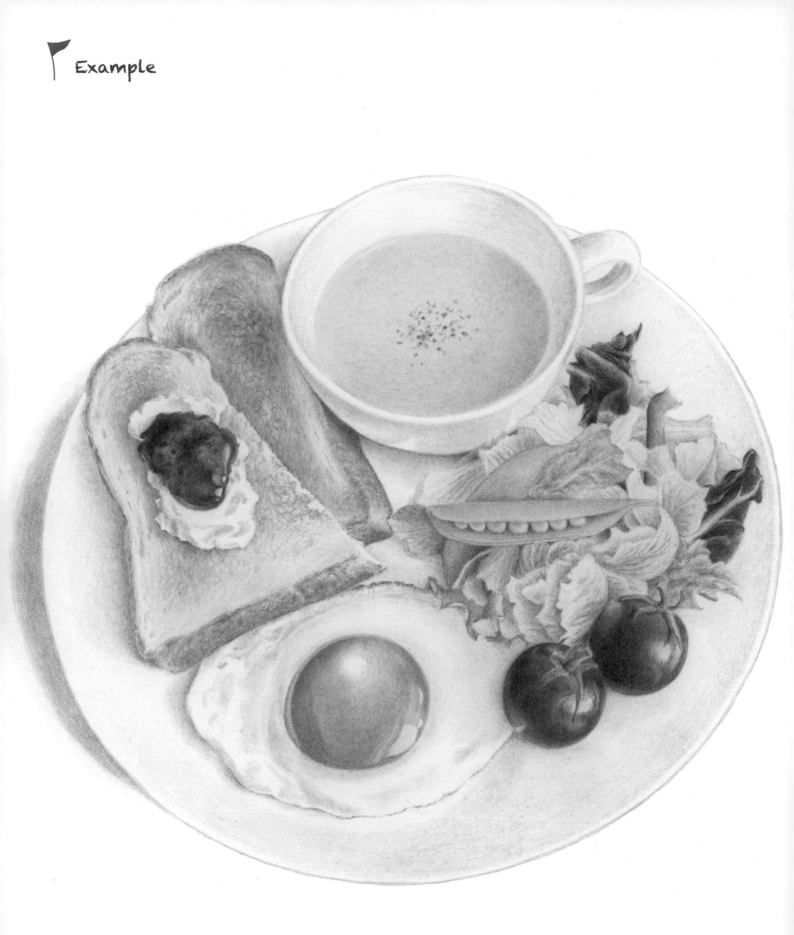

▸ **A tear-out practice sheet can be found on page 121.**

Drawing a Croquette Sandwich

GOAL Let's color a croquette sandwich filled with lots of delicious ingredients. Create the distinctive textures of the crunchy croquette, the soft bun, the thick aurora sauce, the crisp lettuce and the crinkled paper wrapping.

Key Points for Drawing

Take care to color the difference in texture between the top and underside of the bun.

Colors Needed

Bun

| 102 Cream | HB122 Jaune Brillant | 109 Dark Chrome Yellow | 187 Burnt Ochre |
| 180 Raw Umber | 190 Venetian Red | 177 Walnut Brown |

Aurora Sauce

HB122 Jaune Brillant

109 Dark Chrome Yellow

102 Cream

187 Burnt Ochre

184 Dark Naples Ochre

Take note of the crisp texture of the shredded cabbage.

Cabbage

171 Light Green

140 Light Ultramarine

264 Dark Phthalo Green

151 Helioblue Reddish

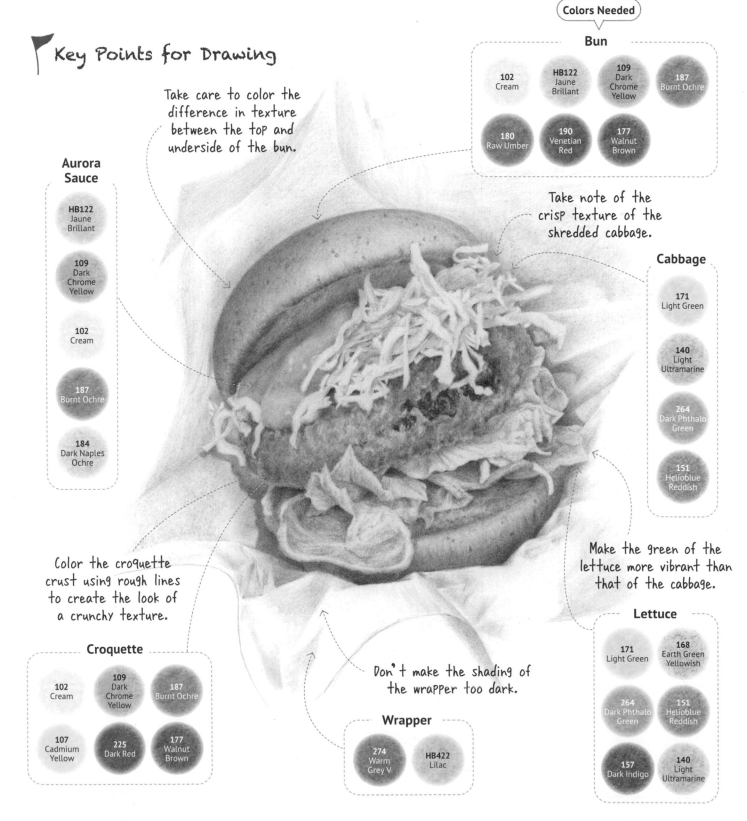

Color the croquette crust using rough lines to create the look of a crunchy texture.

Make the green of the lettuce more vibrant than that of the cabbage.

Croquette

| 102 Cream | 109 Dark Chrome Yellow | 187 Burnt Ochre |
| 107 Cadmium Yellow | 225 Dark Red | 177 Walnut Brown |

Don't make the shading of the wrapper too dark.

Wrapper

274 Warm Grey V | HB422 Lilac

Lettuce

171 Light Green	168 Earth Green Yellowish
264 Dark Phthalo Green	151 Helioblue Reddish
157 Dark Indigo	140 Light Ultramarine

Key Points for Drawing the Croquette, Bun and Aurora Sauce

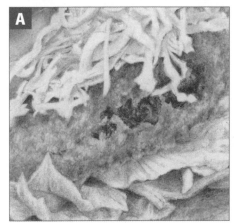

A

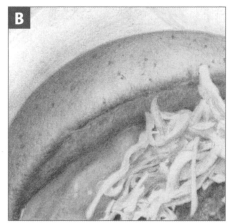

B

Leave small shiny areas uncolored.

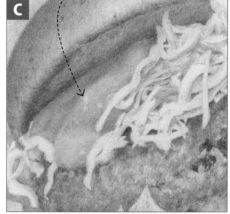

C

Lightly color the entire area of the croquette crust using 102 , and then with 109 and 187 , stand the pencil tip upright and randomly color in rough lines using strong pressure over the entire area. Use 107 in certain places to add rough lines too. For the dark brown sauce, layer 177 on 225 .

Use 102 to lightly color the entire area of the bun halves, and then lightly layer HB122 and 109 . On the outer portions of the bun halves, use 187 to create gradation in the dark areas and add random dots. On the inside of the bun halves, along with the colors above, use 180 to draw in fine shading, add a toasted look around the edges using 190 , and layer 177 in the dark areas.

Color the aurora sauce with HB122 , 109 and 102 while leaving the small highlights white, and add 187 and 184 to the shadows to finish.

Key Points for Drawing the Cabbage, Lettuce and Wrapper

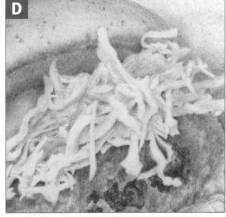

D

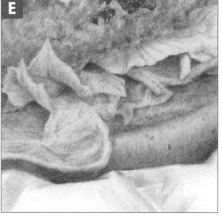

E

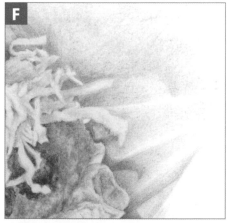

F

For the shredded cabbage, lightly color the entire area using 171 , and then lightly layer the shading with 140 . Layer 264 and 151 in the dark shading inside the sandwich to create a three-dimensional effect.

Lightly color all of the lettuce using 171 , and differentiate light and shadows with 168 , 264 and 151 . For particularly dark shading, color with 157 , and then draw in the fibrous veins using 140 .

Color the shadow of the sandwich cast on the wrapper darkly using 274 . Create the light and shadows of the wrinkles on the wrapper by carefully coloring with HB422 to express the texture of the paper.

Quick Tip

Take care to create different textures when drawing the various sandwich fillings!

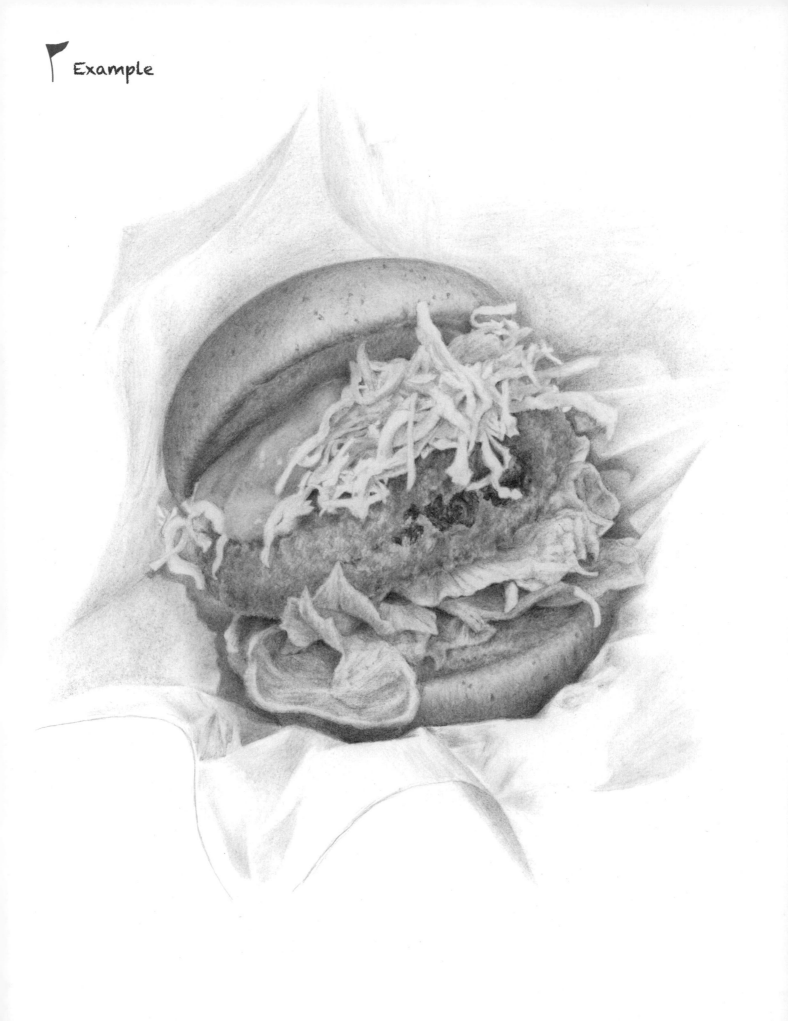

▶ A tear-out practice sheet can be found on page 123.

Drawing a Pomeranian

GOAL Here, we'll color a Pomeranian with gorgeous fluffy fur. The key to creating animal portraits is to realistically depict the fur. It's best to take your time drawing the dark areas of shading in the fur little by little. When depicting the light whiskers, start the outline on one side, and then carefully define the outline on the other side, leaving thin uncolored areas.

Key Points for Drawing

Colors Needed

Fur

HB122 Jaune Brillant | 180 Raw Umber | 187 Burnt Ochre | 177 Walnut Brown | 274 Warm Grey V | 271 Warm Grey II

With animals, it's all in the eyes! Take care not to color the tiny highlights in the pupils.

Pupils
199 Black

Eyes
180 Raw Umber
199 Black
190 Venetian Red

Nose / Mouth
157 Dark Indigo
177 Walnut Brown
199 Black

Carefully pick up and color the shading to express the flow of the fluffy fur.

Be careful to leave the fine whiskers uncolored.

Make fine adjustments in the amount of pencil pressure you apply to create the difference in texture of the long and short hairs.

Add faint shading under the jaw to create a three-dimensional effect.

Shadow
274 Warm Grey V

Short Hairs on Head, Chest, Body, Legs and Paws
190 Venetian Red
191 Pompeian Red

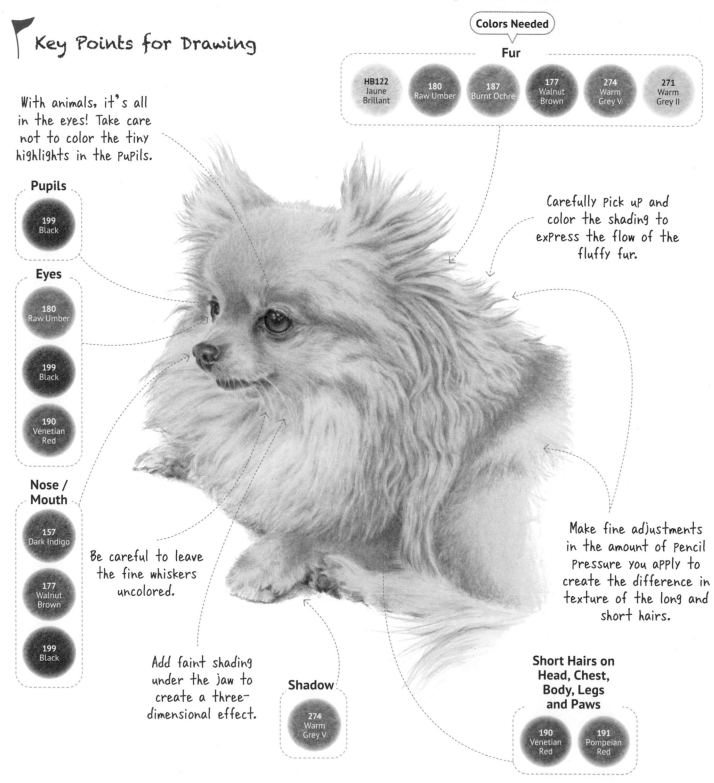

Process and Key Points

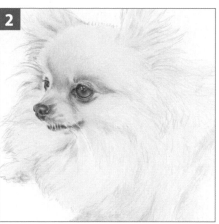

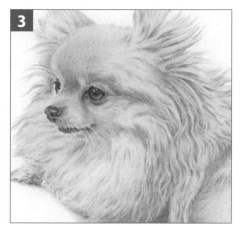

1 Use HB122 to lightly color the entire area and create a base layer, and then use 180 to color the dark areas and shading of the fur.

2 For the fur around the face, use 187 and 180 to add shading and create a three-dimensional effect.

3 Use 274 and 271 to add shading under the jaw, but make sure not to color the whiskers. Lightly layer all the fur with HB122 and patiently add shading using 180 and 177 . For the fine hairs on the head, chest, body, legs and paws, lightly layer 190 and 191 to express the distinctions.

Process and Key Points for the Pupils, Nose, Mouth and Eyes

Lighten with an eraser.

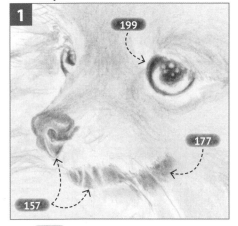

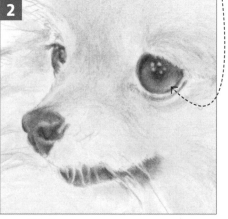

1 Use 199 to color the pupils, making sure not to color the white sparkles. Color the mouth with 157 , staying aware of the shape of the nose and leaving the whiskers uncolored. Use 177 for the corner of the mouth.

2 Use 180 to color the eyes, and then use 199 on the top part to add dark shadow. Next, use an eraser on the bottom half to fade the color and impart the look of transparency. For the nose and mouth, gradually layer 199 to make them darker.

3 Sharpen 199 and use it around the eyes. Add a little warmth under the eyes with 190 .

> **Quick Tip**
> Rather than drawing one hair at a time, draw them in rough sections and then color softly along the flow of hair.

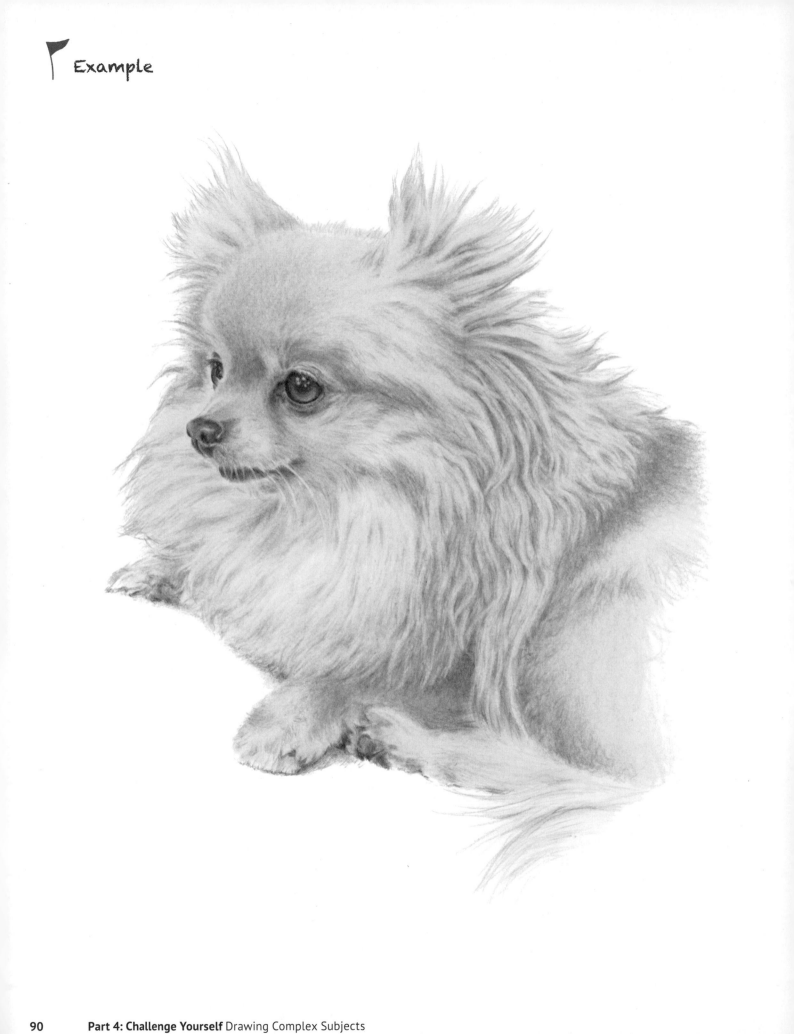

Example

Part 4: Challenge Yourself Drawing Complex Subjects

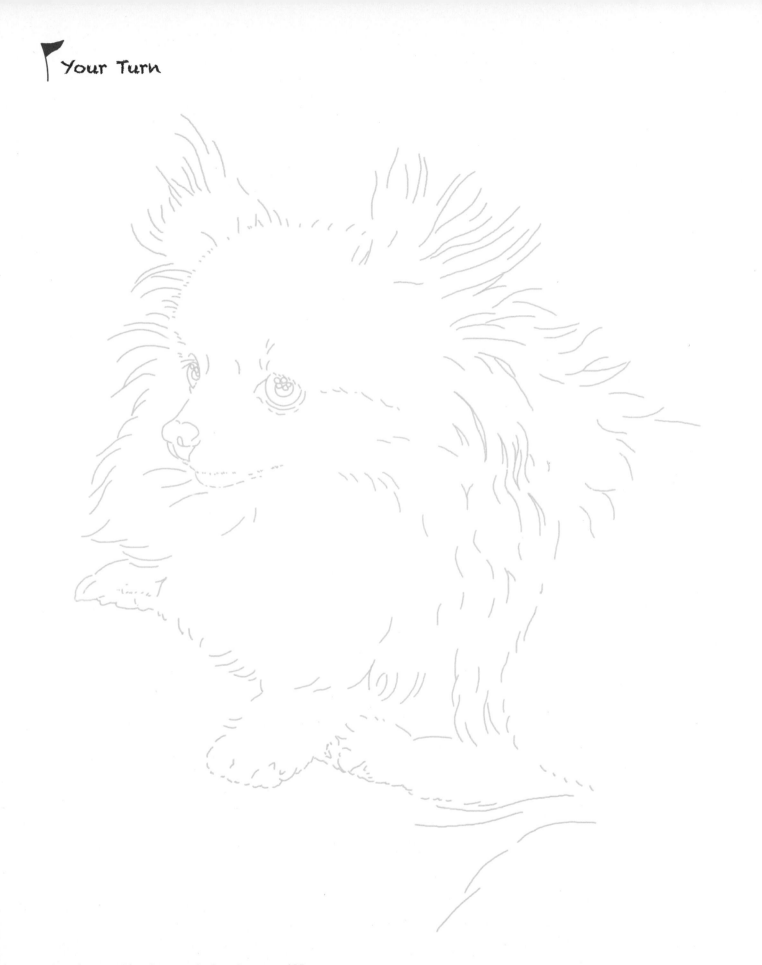

▶ A tear-out practice sheet can be found on page 125.

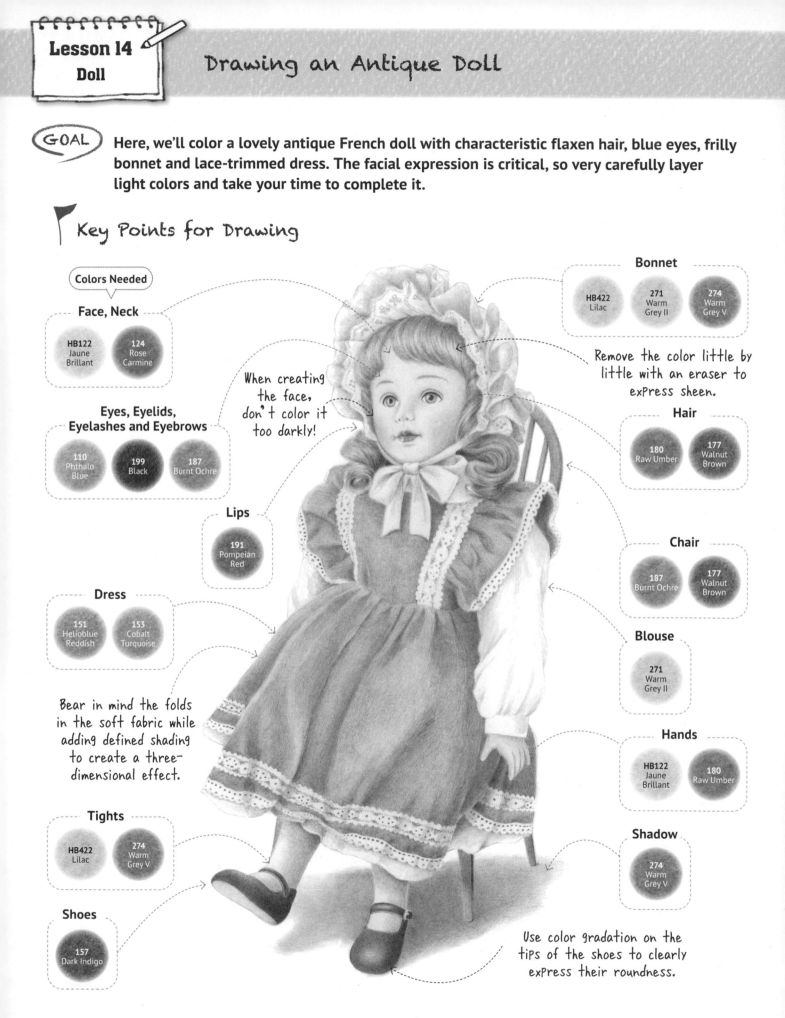

Drawing an Antique Doll

GOAL Here, we'll color a lovely antique French doll with characteristic flaxen hair, blue eyes, frilly bonnet and lace-trimmed dress. The facial expression is critical, so very carefully layer light colors and take your time to complete it.

Key Points for Drawing

Colors Needed

Face, Neck

HB122 Jaune Brillant | 124 Rose Carmine

Eyes, Eyelids, Eyelashes and Eyebrows

110 Phthalo Blue | 199 Black | 187 Burnt Ochre

When creating the face, don't color it too darkly!

Lips

191 Pompeian Red

Dress

151 Helioblue Reddish | 153 Cobalt Turquoise

Bear in mind the folds in the soft fabric while adding defined shading to create a three-dimensional effect.

Tights

HB422 Lilac | 274 Warm Grey V

Shoes

157 Dark Indigo

Bonnet

HB422 Lilac | 271 Warm Grey II | 274 Warm Grey V

Remove the color little by little with an eraser to express sheen.

Hair

180 Raw Umber | 177 Walnut Brown

Chair

187 Burnt Ochre | 177 Walnut Brown

Blouse

271 Warm Grey II

Hands

HB122 Jaune Brillant | 180 Raw Umber

Shadow

274 Warm Grey V

Use color gradation on the tips of the shoes to clearly express their roundness.

Process and Key Points for the Face and Hair

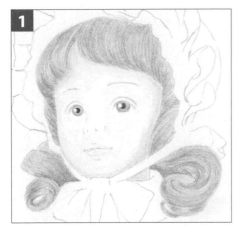

1

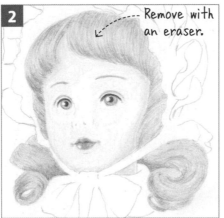

2

Remove with an eraser.

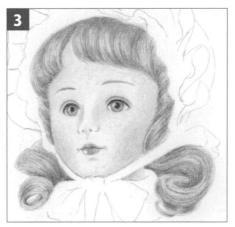

3

Use `HB122` to lightly color the whole face and neck. For the eyes, color using `110` while leaving the highlight uncolored. Use `199` for the pupils and lightly color the lines of the eyelids using `187`. Color the hair with `180`, following the flow of the waves and adding tresses.

For the eyelashes, use `199` to draw lines. Color the eyebrows with `187` and use `191` on the lips while avoiding the glossy areas. Use an eraser on the hair to create the sheen.

Darken the shading on the face using `HB122` and lightly color the cheeks with `124`. For the hair, use `177` in places to add tresses that give the impression of locks of hair and layer to darken the shading.

Key Points for Drawing the Bonnet, Dress, White Tights and Shoes

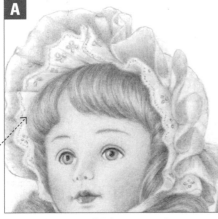

A

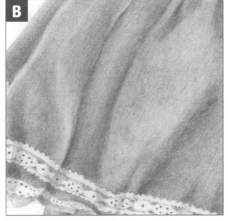

B

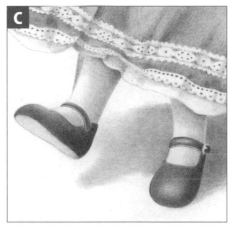

C

For the bonnet with its many pleats, use `HB422`, `271` and `274` to add fine shading and create a three-dimensional effect.

In order to express the softness of the dress fabric, gently layer `153`. Take plenty of time to create the lace patterns and make good use of the white paper by leaving it uncolored.

To create the white tights, color lightly in the shading areas using `HB422` and `274` to finish. For the shoes, pay attention to the rounded form of the shading while coloring with `157`.

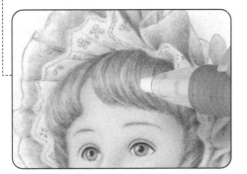

Erase the hair further to emphasize the sheen.

> Quick Tip
>
> Make the hair look three-dimensional by clearly defining shiny areas with an eraser and adding shading in certain parts too!

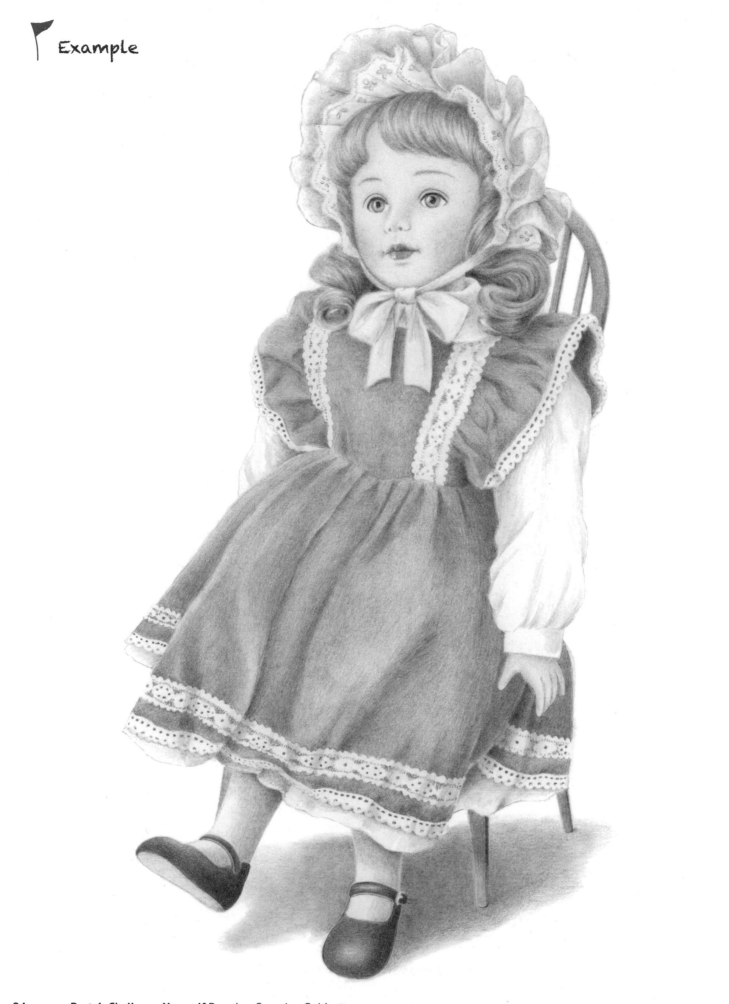

Your Turn

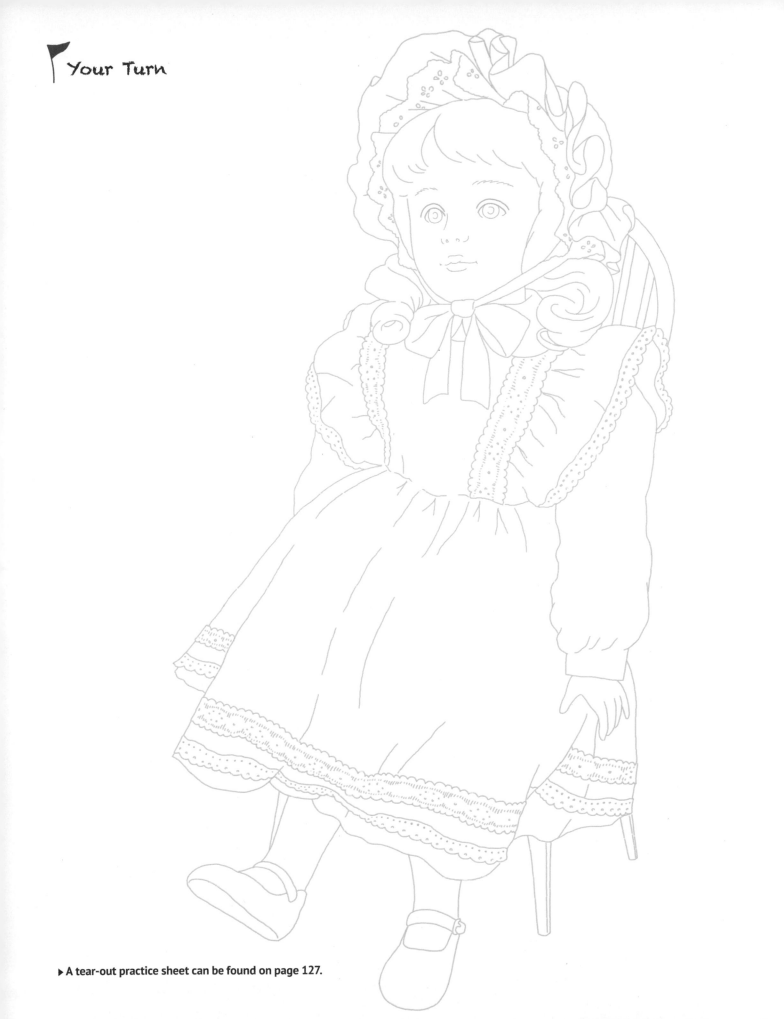

▶ A tear-out practice sheet can be found on page 127.

In Closing

I hope you've enjoyed doing colored pencil drawing while completing the many lessons in this book!

You can use the techniques you've learned in this book to create your own colored pencil drawings and display them, showing your completed work to your family and friends, and even share your own original work on social media with the added excitement of having many people see it. Colored pencils are a very free medium and there is a wide range of drawing methods and techniques in addition to those introduced here. I hope you'll keep exploring and practicing to have even more fun with colored pencil drawing!

—Yoshiko Watanabe

A Place to Meet the Sea